why the museum matters

y

yale
university
press
new haven
and
london

daniel h.

weiss

X

why the

museum

matters

Yale University Press books may be purchased in quantity for educational, business, or promotional use. For information, please e-mail sales.press@yale.edu (U.S. office) or sales@yaleup.co.uk (U.K. office).

Set in Adobe Garamond type by BW&A Books, Inc.
Printed in the United States of America

Library of Congress Control Number: 2022937292
ISBN 978-0-300-27685-5 (pbk.)
eISBN 978-0-300-26935-2

A catalogue record for this book is available from the British Library.

10 9 8 7 6 5 4 3 2 1

yalebooks.com/art

also by daniel h. weiss

In That Time: Michael O'Donnell and the Tragic Era
 of Vietnam
The Morgan Crusader Bible
Art and Crusade in the Age of Saint Louis
Remaking College: Innovation and the Liberal Arts
 (coeditor with Rebecca Chopp and Susan Frost)
The Book of Kings: Art, War, and the Morgan Library's
 Medieval Picture Bible
 (coeditor with William Noel)
France and the Holy Land: Frankish Culture at the End
 of the Crusades
 (coeditor with Lisa Mahoney)

For my Met colleagues
and
in memory of
William G. Bowen

contents

Introduction 1

Part I. A Selective History of the Art Museum

one Ancient Antecedents 11

two Reinvention 23

three The American Experiment 41

Part II. Why the Museum Matters

four A Place of Consequence 53

five A Forum for Ideas 75

six An Enterprise for Community 99

seven A Source of Identity and Connection 125

Part III. New Directions

eight Evolving Mission/Preserving Values 145

nine Museums for a New Generation 152

Notes 169

Acknowledgments 183

Index 185

introduction

It is difficult to argue with the idea that museums matter. Those of us who live in large cities are surrounded by an astonishing variety of them, and the rest of us are touched by them in one way or another. The cultural life of every city, and most communities of any size, is in large part defined by museums. This is true not only in Europe and the United States but also, increasingly, around the world. In China alone, new museums are opening at a rate of about one per week, a trend likely to continue well into the future. The nation-building work underway in Qatar, the United Arab Emirates, Kuwait, and Nigeria as well as China has made cultural infrastructure, and particularly the establishment of art museums, a priority for new investment and international cooperation. In the United States, immediately prior to the Covid-19 outbreak there were more than 35,000 museums of all types in operation; they accounted for 750,000 jobs and contributed $50 billion annually to the country's economy. For any number of reasons, it would appear that museums matter a great deal.

Public art museums, some vast and others more modest, are complex enterprises, serving not only as repositories for objects of aesthetic or historic interest—and as engines of the economy—but also as civic monuments. Like the venerated sanctuaries of ancient Greece, the soaring cathedrals of the European Gothic Age, and the opulent palaces of Renaissance Italy, art museums have become the secular temples of our time, revealing a great deal about our values, politics, cultural preferences, and identity.

The American art museum as it exists today—a civic, mission-driven enterprise offering public access to art, education, entertainment, community, and, increasingly, political controversy—is widely recognized as a distinctive contribution to the cultural world. But its essential character is a reliable descendant of the European Enlightenment. The first truly public museums of the early modern era—the Capitoline in Rome, followed by the British Museum in London and the Louvre in Paris—had by the end of the eighteenth century emerged as enthusiastic participants in the nation-building that was revitalizing much of Europe. In so doing, these vital, community-oriented institutions helped to redefine the urban experience not only for the wealthy and educated but also for the emerging middle class, which was essential to the success of the social and political moment. Within the United States, in the era of post–Civil War Reconstruction and Gilded Age prosperity, the European version of the encyclopedic art museum became established on a large scale with the founding of the Metropolitan Museum of Art in New York and the Museum of Fine Arts in Boston,

both in 1870.[1] Within a few decades, with the advent of Progressive Era reforms, the museum phenomenon had become an engine of social progress and a central feature of the cultural landscape of most sizable cities: the Philadelphia Museum of Art was chartered in 1876, the Corcoran Gallery in Washington, D.C., in 1869, and the Art Institute of Chicago in 1893, among many others. Successfully established on American soil, art museums began to proliferate and evolve in myriad ways that distinguished them from their more traditional European ancestors.

The extraordinary success of the art museum movement throughout the United States can be measured by the depth and remarkable diversity of collections and programs, expansion of local and international audiences, growth of philanthropic support, and admirable resilience through good times and bad. But at the same time, we acknowledge that the current moment has brought unprecedented challenges that call into question museums' fundamental purpose, efficacy, and civic function. It is therefore something of a paradox to observe that, while public art museums have become vital contributors to many communities, critiques from these same communities say their museums are falling short, with some calling for fundamental change to museums' core purpose and questioning if they benefit those they are supposed to serve. Although this debate has become acrimonious and occasionally histrionic, it has provided—for those who will listen—an opportunity for reflection on all sides, and a chance to generate new thinking on how the museum can improve in its mission to be a useful and relevant cultural resource for all.

For most of my adult life I have been closely associated with

museums—as a scholar and university professor, as a trustee at various institutions, as a cultural tourist, and, most recently, as president and CEO of the Metropolitan Museum of Art, where I have had the chance to reflect carefully on questions of institutional mission, values, and evolving purpose. Like many of my colleagues, I have long recognized that, for many people, life would be unimaginable without these extraordinary institutions to enrich our daily experience, guide us in our search for beauty, inform our understanding of the world, give form to our ruminations, and help us to build more enlightened and meaningful lives. Yet I also recognize that some may find museums to be little more than an occasional distraction or momentary amusement, if they matter at all. Not everyone believes that museums are essential to a functioning society, even if most agree, for any number of reasons—intellectual, social, aesthetic, and practical—that they are nonetheless a good thing to have.

I embarked on writing this book just before the spring of 2020, when the world shifted on its axis as a result of the Covid pandemic, the national protest movements seeking racial and social justice, and the economic turmoil that was to follow. These factors and others, such as polarization in our national politics at levels unseen since the Civil War, have contributed to a sustained national crisis that is revealing ominous signs of further change. My original idea, before the crisis engulfed us all, had been to explore the state of the American art museum—its foundational vision, evolving reality, and most compelling critiques, as well as its enduring importance—within a larger historical and social frame. I also wanted to give careful thought to the observations

held by some that these venerable institutions were increasingly becoming victims of their own success—or, to put it more directly, that they were losing their way and, in so doing, sowing the seeds of their own destruction. Although these criticisms are not new, one consequence of recent events has been that these concerns are seen to be increasingly urgent, perhaps because museums are recognized as important in our lives and communities. If no one really cared what museums did, there would be little reason for such impassioned criticism and call for change. With these considerations in mind, I embarked on this book with a renewed sense of purpose and with the conviction that there is something of fundamental importance about the art museum to our society and our democracy. I was confident that in making the case for why the museum matters I would have the opportunity to reflect on my reasons for thinking so and, along the way, perhaps propose a few suggestions for improvement.

My primary focus in this book is what we call encyclopedic art museums, particularly in the form envisioned and created in the United States. These institutions, as distinguished from more specialized collections, aspire to collect art and archaeological materials from the great epochs of human history across the vast geographies of the world. Although my observations are intended to encompass the widest range of these institutions, my specific frame is often the largest of these places, especially the Metropolitan Museum of Art, which I know best. In exploring both the history and performance of the museum idea in the United States, I wanted to set out my own views about why it matters so much, especially now, and what is at greatest risk if

it is lost—even as I concede that I have no special knowledge about what lies ahead for our museums, any more than I do for society in general. Like many of us, I have deep concerns about the fragile state of our democracy and the efficacy of our civic institutions to help us find a productive way forward. Yet, as a museum leader, I am convinced that the cultural world can play an essential role on this journey, in part simply by bringing us together in a shared, uplifting purpose but also by offering us perspectives that are larger than our own and that might help us to navigate toward a more just and equitable future.

Written for the general reader rather than the specialist, *Why the Museum Matters* is intended to offer an accessible narrative on the origins and history of the art museum idea, the larger purposes of such institutions, and what steps we might take for museums to achieve a better future. I provide a perspective on the evolving idea of the museum, explore some of the pressing issues before us, and offer ideas on a way forward for a vital enterprise dedicated to the public good. I do not write as an activist or a partisan, and this book is not a polemic but rather is intended to offer a balanced assessment of the issues, inform and engage readers, and make the case for how museums must continue to evolve in our complex and riven society. My hope is that this book will help us find common ground, value what these institutions represent, and suggest pathways forward that unite us rather than divide us—which is the only way forward if museums are to remain meaningful in the years ahead.

The museum movement in the United States has been a resounding success for the many ways it has improved our cultural lives and, more broadly, for the contributions it has made to many communities. The seismic social changes wrought by recent events have led to significant progress in the museum world, some of it a long time coming and especially welcome. But it has been difficult and sometimes painful as well. In the chapters ahead, I explore the American art museum both as an evolving idea within the larger arc of human history and in terms of its specific role and meaning today. The book is divided into three sections, the first of which outlines a few central themes in the long history of art collecting, a phenomenon begun in the ancient world and evidently linked to the essential practices of civilization from its earliest days. The middle section of the book examines the roles that museums play in our world today, attempting to answer the question about why, and in what ways, I believe that the museum does matter. In the last section, I offer some thoughts about what is at stake for museums if they are to continue serving a useful purpose, and ideally to thrive, in an uncertain future.

In reflecting on the place of art museums in the world today, my thoughts are drawn to the ancient Greek sanctuaries of Delphi and Olympia, which were in their own way among our earliest museums. These haunting and evocative sites, filled with works of timeless beauty and historical resonance, were dedicated to a shared set of values, beliefs, and cultural practices—what the Greeks of the ancient world referred to as Panhellenism—and were

where they found common ground in a world otherwise riven by competition and conflict. Within these special places, each dedicated to a specific purpose—athletic prowess at Olympia and sacred ritual at Delphi—the diverse city-states of the Greek world came together to celebrate what united them while also recognizing the distinctiveness of human achievement. In so doing they found enduring value in concord and shared purpose. What makes these places alive for us today, in some ways like our own museums, is the genius of their creative expression as realized in such an astonishing array of individual objects—from the iconic to the epic—within a sublime setting and in conversation with the larger world.

Part I

A Selective History of the Art Museum

1 ancient antecedents

The origin story of the encyclopedic art museum is both longer and more complex than its Enlightenment history would suggest. Based on the available evidence—archaeological, historical, and literary—the concept, or more precisely the very human impulse to create, venerate, interpret, and display works of art, has always been with us. The related practice of building collections of art also has a long history, traceable to the first cities of the ancient Near East. For example, the Neo-Babylonian Palace of Nebuchadnezzar II (who ruled in the sixth century BCE), included, along with his famous hanging gardens, a public art collection that had been assembled from disparate cultures across several millennia and vast distances throughout the ancient Near East. This "proto-museum," consisting largely of sculptures from the great civilizations of Ur, Neo-Assyria, Mari, and the Hittites, among others, would have demonstrated the

power of the great Babylonian king (since the objects had mostly been obtained through conquest); but so too did it demonstrate his keen interest, and presumably that of his subjects, in the cultural heritage of the world they were quickly making their own.[1] When the Babylonian Empire fell to the Achaemenids in 539 BCE, the collection passed to the Persian conqueror, Cyrus the Great, who had much the same acquisitive ambition. By that time the collection had grown to include the famous limestone stele of Naram-Sin of 2200 BCE, a sculpted narrative recounting the Akkadian king's conquest of the "Mountain People" that is generally recognized as the earliest representational landscape in the history of art.[2] Cyrus and his armies also appropriated from their enemy the stele of the Babylonian king Hammurabi, the first known law code, dating to 1750 BCE. Interestingly, the law code had been plundered before, in the twelfth century BCE, by the Elamite king Shutruk-Nahhunte; he brought it to Susa, and from there Nebuchadnezzar took it to Babylon.[3] These works of unparalleled artistic and historic importance found their way—first through conquest and plunder and later through archaeological excavation and political negotiation—from one collection to the next, eventually reaching the Louvre in Paris, where they are on view today. Long before the museum concept was "invented" during the European Enlightenment, ancient societies were occupied with the business of cultural appropriation, preservation, interpretation, and public display. Such collections must have served a variety of purposes, from political self-aggrandizement to cultural exploration—which is to say that

they were creating their own version of the museum as we might recognize it in the modern world.

The practice of establishing collections of art and historical artifacts was even more prevalent in ancient Greece. Following a succession of natural disasters and military conquests that had effectively silenced the Greek world in the centuries after the Trojan War, by the first millennium BCE city-states were gradually reentering the light of civilization, and early on they were establishing historic collections of art and relics, often placed within purpose-built structures designed for public access. The earliest of these collections consisted mainly of devotional objects and historical relics that were generally placed in temples and shrines. Although religious or devotional objects were widespread throughout the ancient world, from the eastern reaches of the Persian Empire to the Carthaginian settlements in southern Spain, these works were no longer consigned to the oblivion of subterranean graves; rather, the Greeks were placing them on public view within larger collections that presented narratives associated with a specific setting and context.[4] Throughout antiquity public collections played an essential role in nation-building by helping to shape an origin myth that defined the character of a community. The objects, their provenance, and the stories they told contributed to inventing the history of a people—some of it real and some imagined—that became part of a shared identity for an emerging city-state. As the eminent historian and archaeologist John Boardman has written about these collections: "The crux is identity. . . . Much seems to have to do with establishing

the credentials of a state or cult, or even of an individual ruler, but later evidence shows that 'democracies' were no slower to seek authenticity by the same means."[5]

For many of the objects in these ancient collections, a known and interesting provenance added richness to their stories, which in turn generated greater public interest. Visitors traveled long distances to see celebrity objects, and the more fabulous their history, the more attention the objects attracted. For example, Pausanias, the intrepid geographer and cultural writer of the second century CE who recorded his visits throughout Greece in ten books, described a famous scepter he encountered while visiting the city of Chaeronea in Boeotia: "The people of Chaeronea honor most the scepter which Homer says Hephaistos made for Zeus, Hermes received from Zeus and gave to Pelops, Pelops left to Atreus, Atreus to Thyestes, and Agamemnon had from Thyestes. This scepter, then, they worship. . . . That there is something peculiarly divine about this scepter is most clearly shown by the fame it brings to the Chaeroneans."[6]

For city-states across the Greek world, the public display of art—in the form of votive objects, heroic sculptures, or painted narratives on vases or walls—provided an essential means of connecting with the past. Boardman has described these collections, which were selective and curated, as the "first museums" owing to their emphasis on using narratives and storytelling to shape national identity.[7] Drawing on what was known and valued in the historical record and supplemented by myth, these Greek collections and the monuments that contained them had become an early form of national museum, and in that sense might be

compared to the National Archaeological Museum in Athens, the Rijksmuseum in Amsterdam, and Tate Britain in London. As was the case in so many aspects of life in ancient Greece, collection-building became a competitive enterprise, which was clear at such Panhellenic sites as Olympia and the sanctuary at Delphi, which had assembled the individual shrines of twenty-three Greek city-states, each of which presented in architectural and sculptural form a distinctive version of its own history and national identity.

These sites were then, and remain today, important to the local population, but they were also of great interest to visitors from near and far. On visiting the Athenian Acropolis, Pausanias offered a lengthy description of the magnificent and famous art and monuments he encountered, which, by the time he arrived, had been on public view for more than five hundred years. In describing the architecture of the Propylaea and the paintings displayed nearby, he wrote: "There is but one entry to the Acropolis. It affords no other, being precipitous throughout and having a strong wall. The gateway has a roof of white marble, and down to the present day it is unrivalled for the beauty and size of its stones. . . . On the left of the gateway is a building with pictures. Among those not effaced by time I found Diomedes taking Athena from Troy, and Odysseus in Lemnos taking away the bow of Philoctetes. There in the pictures is Orestes killing Aegisthus."[8] Pausanias went on to describe the wealth of offerings throughout the complex, including the architecture, paintings, and sculpture that he found to be visually impressive as well as informative in their recounting of the actual and fictive history of Athens. As

Boardman has observed, such art collections not only celebrated the glories of the past, they also provided essential information "as readily as any text, especially to a mainly illiterate society."[9]

For the Greeks, art collections had become an essential component of civic identity and served as a valued public resource. By the time of Alexander the Great (336–323 BCE) these ideas had been disseminated by his conquering armies from Britain to India—five thousand miles from west to east. As these practices of collecting and display evolved, so too did the art profession, including "such practices as the rise of royal collecting, the development of connoisseurship, the beginnings of the history of art, learned tourism, the writing of guidebooks, and the creation of new viewing contexts including 'art galleries.'"[10]

As evidenced in myriad forms throughout antiquity, the widespread reliance on material culture—objects, artifacts, relics, and art—helped shape historical narratives, define civic identity, and enrich experience. For the Romans, whose empire had by the second century BCE absorbed most of Alexander's world, art collecting had expanded to become a major commercial enterprise, focused mainly on the acquisition and display of statuary, painting, and other portable art made by Greek artists. Evidence of a substantial luxury trade can be found throughout the ancient sources—literary, artistic, historic, and archaeological—but perhaps most spectacularly from the abundance of shipwrecks of the period. With the advent of technically sophisticated marine archaeology, an astonishing array of underwater sites have been recovered in recent decades. They have yielded sculptures of marble and bronze, carved capitals and other architectural elements,

bronze furniture, marble lampstands and candelabra, and countless decorative objects, as well as substantial information about trade routes, art markets, and popular taste. Perhaps the most remarkable of these are the two life-size bronze warriors found in 1972 off the coast of Riace in southern Italy.[11] Made by masters in fifth-century BCE Greece, the Riace bronzes attest to the sublime quality of ancient Greek sculpture and to the lively trade in art across the Mediterranean.

The ancient art market was complex and fraught with risk, not only of the maritime kind. Most dealers operated legitimate businesses that traded throughout the Mediterranean basin and complied with agreed-upon practices and evolving laws concerning rightful ownership. Yet within this world there was also a great deal of looting and plunder, much of it countenanced by Roman law. The practice, known by the Latin term "*manubiae,*" gave Roman military leaders permission—more through custom than actual law—to loot the property of their enemies as a reward of conquest. Only rarely, when the looting was so egregious that it garnered widespread attention, was the practice limited. The most notorious of these cases involved the rapacious Sicilian governor Gaius Verres, who was successfully prosecuted by Cicero in a celebrated trial.[12] Verres, by every measure a thoroughgoing criminal as well as an assiduous plunderer of Greek art, was eventually convicted of corruption (the least of his crimes) and forced into exile. At Cicero's instigation, much of the art stolen by Verres was returned to the temples, shrines, and other rightful owners. In prosecuting Verres early in his career, Cicero rose to fame as a champion of the civic virtues of republican Rome, and

in so doing he established the first principles for legal ownership of art, many of which remain in use today.

Legal plunder in the form of art, gems, gold, and other precious objects, not to mention enslaved human beings, had long been used to reward loyal soldiers and enrich those in power. But following Cicero's decisive victory in the Verres trial, manubiae was increasingly deployed to support public works projects, usually in the form of newly commissioned civic structures, with credit given to the benefactor who provided the funds.

Within Roman society, looted art and other plunder, whether it was destined for personal enrichment or other use, was often assembled for public display in the form of a "Triumph," in which both the conquerors and their goods were paraded through the city. One of the most famous of these events commemorated the Roman capture of Judea in 70 CE by the general and future emperor Titus. This occurred almost exactly five hundred years after the conquest of Jerusalem by the Babylonian ruler and early museum builder Nebuchadnezzar II, who had destroyed the First Temple and looted its treasures, including almost certainly the Ark of the Covenant. Described by Josephus, who witnessed the proceedings, Titus's Triumph consisted of a massive parade replete with floats depicting key battles and the presentation of much plunder, including statuary, gems, human beings, and, most notably, the remaining treasures of the Second Temple in Jerusalem, including a gold menorah, silver trumpets, and a gold Table of Showbread.[13] The looted property and celebratory triumph of the Jewish Wars is depicted in two superbly executed but badly weathered relief sculptures adorning

the interior of Titus's commemorative arch, which was placed in 81 CE on the Via Sacra adjacent to the Forum Romanum, where it remains today.

Among the politically ascendant and socially ambitious members of Roman society, there emerged a new movement that was becoming more civic-minded with regard to the collection and display of art. Cicero was one of the first and most influential of his peers to promulgate the benefits of public art over private collections, which he described as too often sequestered in villas across the Roman countryside, far from public view. Near the end of his life, and despite a substantial personal art collection sequestered within his own villa, Cicero proclaimed: "The Roman people hate private luxury, they prize public magnificence."[14]

Possessing great wealth derived from his own military conquests, Julius Caesar was, like many of his peers, an avid art collector, but he too understood the public benefit—and political utility—of civic projects that could be credited to his beneficence. In the years following his victories in the civil wars and his rise to become *dictator perpetuo* (dictator for life), Caesar sought to bring order and a sense of unity to Rome, goals he advanced primarily through major social and political reforms, but also through large public works projects, such as the eponymous forum he had constructed adjacent to the Forum Romanum at the center of the old city. Caesar's capital plans also included ambitious cultural commissions, including a public art gallery and library to rival the Great Library of Alexandria, which his own armies had only recently destroyed. But Caesar himself would

not live to see these projects through to completion; on the Ides of March in 44 BCE he was assassinated, only two months after being named dictator. These were difficult times to be a member of the ruling class. However, the idea for a public library and museum had taken hold in Rome; it needed only to find a new champion.

Ultimately, the project fell to Gaius Asinius Pollio, an admired humanist, civic leader, and general who had served with distinction under Caesar in the civil wars. Pollio was also an accomplished literary figure, having written a well-regarded and authoritative history of the civil wars. For his wide-ranging accomplishments in law, poetry, public affairs, and especially oratory, Pollio was seen as exceptional, even among his peers. Years later, the eminent rhetorician Quintilian referred to Pollio with singular admiration as a "man for all occasions."[15] Pollio was also a major art collector; among the notable objects in his collection was the so-called Farnese Bull, the largest sculptural group recovered from antiquity.[16] In taking on the project to build a public library and museum at a time of such dramatic political change—and not inconsiderable personal risk—Pollio was surely reaffirming his status as a public benefactor, but there was a great deal more at stake. As a member of the Roman elite, raised under a republican form of government, Pollio was concerned that he was witnessing the erosion of core freedoms that had traditionally been granted to citizens. As Llewelyn Morgan has argued, "Traditional political *libertas* was now severely constrained; what Pollio sought to exploit above all was the possibility of free expression."[17] In building his public library and museum, Pollio

was hoping to impose a cultural bulwark against tyranny by providing unfettered public access to a world of ideas and inspiration such as could be found in books and works of art. In referring to this ambitious project, Pliny commented that Pollio was the first "to make human brilliance publicly available."[18]

Drawing on manubiae from his own military victories, Pollio chose to place his public library and museum within a restored structure of great historical importance, with the apt name Atrium Libertatis (Hall of Freedom), located near the Forum Romanum.[19] Both the prominence of the site and the building's venerable republican history were important to Pollio's purpose in highlighting the symbolism behind his vision. The Monumenta Pollionis, which Suetonius said was "restored with great magnificence," thus became the first public art museum and library in Rome.[20] As the five-hundred-year-old republic gave way to dictatorship, Pollio's new monument was established to support the idea that liberty could still live.

However, Pollio's monument did not endure for terribly long, surviving about a century and a half before the Atrium Libertatis was demolished to make room for the construction of Trajan's Forum as the city continued to evolve and grow. We know primarily from literary evidence that the collection included both Greek and Latin volumes, each placed within its own wing that also contained portrait busts of authors. We know little about the rest of the art collection, other than that it consisted primarily of Greek and some Roman sculpture, with a particular emphasis on Hellenistic works, a style favored by Pollio and many Roman collectors at the time.

In the ancient world the idea of the public art museum, in one manifestation or another, was both ubiquitous and persistent. Yet all versions, from the Babylonians to the Romans, were inspired by two complementary impulses: *to explicate specific themes*—often religious, tribal, or nationalistic—that shaped narratives of collective identity; and *to build community* by contributing to the public good—through ideas, inspiration, knowledge, and pleasure.

2 reinvention

The elements of the public art museum as we know them today were all in place in the classical world—as were many other ideas about how to live thoughtfully and well. But in the years immediately following, and for more than a millennium thereafter, the museum idea was put aside as a new Christian movement swept across Europe, transforming society, art, and culture. The period we recognize today as the Middle Ages was itself a time of exceptional artistic inventiveness as practiced by a multitude of cultures—from the Byzantines in the East to the Franks and Normans in the West—for more than a millennium. The art of the medieval period, including manuscript illumination, the minor arts, sculpture, stained glass, textiles, and especially architecture, added immeasurably to the cultural heritage of Europe; however, the larger societal context was ecclesiastic rather than civic, and museums were not to play

a part. Although the disparate Christian cultures of the period maintained great interest in the collecting, study, and display of art, these were pursued largely by and for the ruling classes rather than the general public, and the ambient was thoroughly religious. For the wider public, access to art was exclusively within the domain of the Church, which prompted the nineteenth-century cultural historian Gustav Friedrich Klemm to refer to churches as the "museums of the Middle Ages."[1]

The invention, or, more accurately, reinvention of public art museums appeared later, during the period known as the Enlightenment, a European social, political, and philosophical movement of the seventeenth and eighteenth centuries that emerged out of Renaissance humanism and promoted the primacy of empiricism, reason over faith, individual rights, and the scientific method. By the eighteenth century, the movement had spread throughout Europe, where it was engaging the most formidable assembly of intellectuals in the history of Western civilization, including Thomas Hobbes, David Hume, Adam Smith, Voltaire, Johann Wolfgang von Goethe, Immanuel Kant, Cesare Beccaria, Edward Gibbon, and Benjamin Franklin. These philosophers, historians, writers, and scientists brought a wealth of diverse ideas to the movement, but most shared a belief in the concept of progress as a unifying ideal and the conviction that civil society required new forms of government that would ensure individual liberty, human rights, the consent of the governed, and the separation of church and state—at least for those they deemed worthy of such benefits, which did not include women, the enslaved, and others from more distant shores.[2] Many En-

lightenment thinkers were forthright in their opposition to monarchy, which still prevailed throughout Europe. Support for more democratic government, scientific progress, and new forms of scholarship inevitably placed greater emphasis on the rights of individuals to education and the acquisition of experience, which in turn led to the rising importance of public spaces such as universities, libraries, and museums. For the twentieth-century philosopher Jürgen Habermas, the creation of public spaces as a means of fostering free and open discourse was a distinctive achievement of the Enlightenment.[3]

Throughout this period, personal art collecting continued to be a highly valued and widespread avocation for those with sufficient resources. It was also a well-accepted social practice for art collectors to open their homes to properly credentialed visitors from abroad, a trend that increased dramatically in the eighteenth century. During this period, culturally motivated travel evolved from an activity reserved for the wealthy into a more universal practice, at least among the educated. In time, this aristocratic tradition came to be known as the Grand Tour, generally undertaken by students or recent university graduates—mostly men, but occasionally women—all of whom were accompanied by a chaperone and usually led by a professional guide, known as a cicerone. A European Grand Tour might last for three or four months, but for some it could be extended to several years if resources and inclination permitted. Travel throughout the great cities of Europe was the usual fare, but the itinerary would always include Italy, often the sites of ancient Greece, and, for the most ambitious, Egypt and the

Roman settlements of North Africa. That the Grand Tour was a widespread and popular phenomenon is well-documented, with personal experiences recorded in myriad forms. One of the more unusual of these "records" may be found on a work of architecture in New York, at the Egyptian Temple of Dendur, now installed at The Met.[4] This remarkable structure has a long and storied history, beginning in 15 BCE, when it was commissioned by the Roman emperor Augustus as a gift to the people of Egypt following his victory over Cleopatra and Mark Antony. The temple, which was transported to New York in the 1960s, was located for most of its history on the banks of the Nile, in a remote region about fifty miles south of Aswan and near the border with Sudan. In the eighteenth and nineteenth centuries, the temple was visited only by the most intrepid of Grand Tourists, a few of whom chose to memorialize their adventure by inscribing their names onto the limestone façade. One of the most notable of these graffitists was an American diplomat named Luther Bradish, who carved his name and the date of his visit into the temple façade in 1821 while on official government business as an emissary for Secretary of State John Quincy Adams.[5] Upon his return to the United States, Bradish became lieutenant governor of New York and later president of the New-York Historical Society, where he served on the commission that voted to establish the Metropolitan Museum of Art. It is unlikely that Bradish could have anticipated that his youthful indiscretion would follow him to New York to become an indelible, if ignominious, part of the great museum he helped to found.

Although the Grand Tour was largely undertaken by men, there were also prominent women who made the tour. One of these was Elizabeth Vassall Fox, a wealthy, highly intelligent, independent heiress to a family plantation in the Caribbean. Lady Holland, as she was known from a later marriage, embarked on a Grand Tour in 1791 that was to last five years. Recording her experiences in a journal that she kept throughout her travels, Holland presented a vivid picture of life as a cultural tourist in the era of the Grand Tour.[6] While visiting the museums of Rome, she commented with the experienced eye of a connoisseur on a newly discovered sculpture: "The new Antinous . . . is among the finest things in Rome. It is of colossal size, and almost perfect; the restorations are very judicious, particularly the drapery."[7] While on her travels, Holland admired the art in local museums and also acquired her own collection of art and antiquities, which later added to her social standing and enlivened the many social events she held at her London home, where she became a celebrated hostess, entertaining such guests as Charles Dickens, Lord Byron, and the Prince of Wales.

While visiting Berlin near the end of her tour, Holland dined with Sir Thomas Bruce, the 7th Earl of Elgin, where he was serving as envoy extraordinary for the British government. A few years later, Bruce was appointed British ambassador to the Ottoman Empire in Istanbul, where he was able to negotiate on his own account for the purchase of the Parthenon sculptures on the Athenian Acropolis. Bruce and Holland were not the only cultural tourists who acquired art and antiquities from the sites they visited. The rising popularity of material culture, which had

resulted from the Grand Tour, was also fueling an unregulated and potentially destructive trade in art and antiquities.

By the middle of the eighteenth century, many young men, and some women, possessing sufficient resources, a sense of adventure, and at least some measure of cultural curiosity embarked on the Grand Tour. Like his father who did so before him, in 1786 Goethe undertook a two-year journey throughout Italy, which he recorded in his travel memoir, *Italian Journey 1786–1788*. Goethe's description of his sublime experience remains in print today, a far more enlightening account than the more abbreviated record left by the American diplomat Bradish. Edward Gibbon, who undertook his Grand Tour in 1764, was so inspired by his Roman encounter, with all of its artistic richness and historic complexity—which was for him a virtual palimpsest of Western civilization—that he decided on the spot to undertake the monumental project that was to become *The History of the Decline and Fall of the Roman Empire*. During his time in the Eternal City, Gibbon would have had much to see and experience, including more than forty private palaces and villas throughout the city and surrounding countryside (each requiring a personal letter of introduction); an abundance of churches, catacombs, and archaeological sites revealing tantalizing evidence of Rome's ancient and medieval past; and a single art museum that had only recently opened to the public: the Capitoline on the Campidoglio.

The Capitoline, which opened in 1734, was not the first public museum in Europe—the Statuario Pubblico in Venice (founded in 1596) and the Ashmolean at Oxford University (founded in

1683) are both earlier—but it was the first truly modern art museum "as an instrument for fostering enlightened ideals of personal cultivation and collective identity."[8]

The new museum in Rome was the brainchild of Marchese Alessandro Gregorio Capponi, a close associate of Pope Clement XII who had served as chief quartermaster of the Apostolic Palaces and as a conservator who supervised the restoration of the Arch of Constantine and several other ancient sites.[9] Capponi shared with his patron a long-standing interest in the cultural heritage of Rome, particularly as it then resided under the authority of the Papal States. As a first step, Capponi persuaded Clement to purchase some 408 antiquities owned by Cardinal Alessandro Albani, who possessed one of the most important collections of ancient art in Italy. Despite his desire to build on the rising popularity of Rome as a destination, much of it driven by the success of the Grand Tour, Capponi was mindful of the adverse consequences of a burgeoning tourism industry. With the rise of cultural tourism throughout Italy, there was a concomitant increase in an unregulated and poorly managed antiquities trade, which Capponi recognized could eventually result in the depletion of Rome's cultural heritage. The establishment of a museum would secure this cultural material where it belonged, while adding to the attractiveness of the city for tourism and the status of the papacy as a political force.

But there were other, more positive reasons behind the idea, as was outlined in the original purchase agreement with Albani, which stated that the collection "be publicly exhibited and arranged . . . for the admiration of many ancient heroes,

who over the years and in literature have made the memory of Rome eternal, [the display thus] affording open access to the curiosity of foreigners and dilettantes and greater ease to youths studying the liberal arts."[10] Capponi, who understood well the significance of what he was creating, also persuaded Clement to locate the museum on Capitoline Hill, which had been an important government center for the city since ancient times. In creating such a prominent museum with a collection of artistic and historic importance, which had been acquired expressly for such a purpose, and in locating it on a historic site, Capponi and Pope Clement established a template that was to be followed in succeeding decades by major museums throughout Europe. Innovative though Capponi's vision was, it certainly owed something—knowingly or otherwise—to the example set long before by fellow Roman Gaius Asinius Pollio. It is also a distinct possibility that the Capitoline collection included objects that had once been owned by Pollio, whose own collection closely paralleled that of Cardinal Albani. Shortly after the Capitoline was opened, subsequent acquisitions added an important collection of early modern paintings, which were housed in an adjacent building.

In a very short time, and owing to the leadership of Capponi and his patron, the Capitoline became an example for the world. Under the leadership of Capponi and his successors, the Capitoline also established the essential organization and professional functions of the modern art museum. Although the British Museum and the Louvre are often credited as the leaders of the Enlightenment-era museum movement in Europe, the Capito-

line in Rome set the standard that others would follow. In the years after the museum's opening in 1734, and with the progressive agenda of the Enlightenment firmly in place, the museum movement was underway in cities throughout Europe, with the British Museum opening to the public in 1759, the Uffizi in 1765, the Pio Clementino in the Vatican in 1771, and the Louvre in 1793.

Among the public institutions to have opened during this period, perhaps none was more closely allied to the Enlightenment ideal than the British Museum. Inspired by the promise of a major gift from the eminent collector Sir Hans Sloane, as well as by the popularity among Britons of the Grand Tour and the model of the Capitoline, the Crown and Parliament were eager to create a comprehensive museum that would be dedicated to *all* fields of human knowledge for the benefit of the public.[11]

Upon his death in 1753, and in consideration of the modest sum of twenty thousand pounds payable to his daughters, Sloane bequeathed his entire library and collection of coins, natural history materials, drawings, and other objects to the British people. In the same year, the British Museum was established by an Act of Parliament, with the provision that sufficient funds be raised by public lottery to acquire foundational materials, which in addition to the Sloane collection, included three libraries—the Cottonian, the Harleian, and the Old Royal Collection—and a suitable building to place them, which was to be Montagu House, a large mansion in Bloomsbury. From the outset, the guiding vision was to create a "universal" museum, the achievement of which John Ruskin later praised as the

"greatest concentration of the means of human knowledge in the world."[12] Not surprisingly, the model for such a wide-ranging museum was not sustainable as a single entity, as the collections continued to grow through new gifts, acquisitions, and the proceeds of museum-sponsored archaeological exploration.

In the decades following the museum's opening, there remained ample opportunity for collection-building through archaeological campaigns or purchases and, on occasion, colonialism in the form of military conquest, as we will see later. The British Museum benefitted greatly during this "age of exploration" in which archaeologists—mostly inspired amateurs dedicated to shaping a new professional discipline—were able to excavate at sites of their choosing and then acquire their finds by negotiating with unwary or indifferent sovereigns, some of whom relied on bribery, and most of whom were uninformed on questions of cultural property. At the time, there were not yet laws regulating or restricting the movement of archaeological finds and other forms of cultural property, which enabled the exploitation of other nations throughout the British Empire during this era of high colonialism.

Among the most productive outcomes of the sponsored archaeological campaigns for the British Museum was the discovery and excavation of the magnificent Neo-Assyrian palaces at Nineveh and Nimrud by three of the most accomplished of the pioneer archaeologists, Austen Henry Layard, Hormuzd Rassam, and Henry Rawlinson. Over the span of several decades, the museum was able to establish the finest and most compre-

hensive European collection of art and artifacts from the ancient Near East.

Of course, the most important objects in the British Museum acquired during this period of freewheeling exploration are the so-called Elgin Marbles, the unparalleled collection of ancient Greek sculptures removed from the Athenian Parthenon and transported to London by Sir Thomas Bruce, the 7th Earl of Elgin.[13] The facts concerning the transaction between Bruce and the Ottoman government, which held dominion over Greece, remain in dispute since there is no authoritative documentation concerning the purchase. The controversy of the Parthenon sculptures certainly involves long-standing legal questions under British and international law, but even more important are the enduring ethical questions that some raise about the claim of the Greek people to ownership of their most profound cultural legacy. From the time Bruce sold the collection to the British government in 1816, there has been controversy and ongoing public debate, with British voices such as the poet Byron in the nineteenth century and the critic Christopher Hitchens in the twenty-first advocating for restitution.[14] Despite divided public opinion in Britain and elsewhere, thus far the British government and the courts have maintained that the Athenian sculptures remain the legal property of the British government.

As a result of ongoing expansion and increased specialization, the British Museum collections soon exceeded the available space at Bloomsbury. In 1880, the natural history collection was carved off and given a new and independent home in South

Kensington, and nearly a century later, in 1973, the library became an independent entity, finally moving to its own building in St. Pancras in 1997. The British Museum itself remained focused on building its encyclopedic collection of art, historical artifacts, and archaeological materials. With some eight million objects, these collections are today among the largest of their kind in the world.

If the British Museum broke new ground with its ambitious vision to provide universal access to all knowledge, the founders of the Louvre were at the same time developing a more focused plan, but one that was no less ambitious. Like most European cities of the eighteenth century, Paris was fully occupied with Enlightenment ideas, which in the cultural and intellectual sphere included the creation of new public spaces, including universities and museums.[15] The earliest call for a public museum in Paris came in 1747 from the critic Étienne La Font de Saint-Yenne, who proposed that the vast royal art collection be put to greater use since, at the time, it was largely languishing in storage or sequestered from public view at Versailles and other royal residences. La Font further proposed that the new museum be placed within the Louvre: the historic palace had vast spaces suited for purpose, was already the seat of the Académie Royale de Peinture et de Sculpture, and was conveniently located in the center of Paris. The idea of a municipal art museum soon had many supporters, which in turn garnered an equal number of proposals. As the debate around a permanent art museum ensued, the government moved quickly with an interim plan and by 1750 had opened a modest temporary gallery displaying

some one hundred paintings in the Palais du Luxembourg. Although the new gallery was relatively small, consisting of four rooms, the quality of the works exhibited was uniformly high, including paintings by such masters as Raphael, Titian, Rubens, and Van Dyke.

By 1776, after much public discussion and debate, the Grande Galerie of the Louvre was finally chosen to be the home for the new museum. In choosing this vast and impressive space (at the time of its dedication, the gallery was 460 meters long, making it one of the longest and most imposing rooms in the world), the designers of the new museum were alert to competitive developments elsewhere—especially in London and Rome—and were seeking with their gallery to capitalize on "the spectacle of immensity that first meets the eye."[16]

Enlightenment thinking and its consequent action also produced a great deal of political upheaval in France, with rising public insistence on change and more democratic forms of government. The French Revolution, an unintended and ultimately tragic result of such elevated thinking, was devastating to the population and destabilizing to the nation, but apparently not to the progress of the new art museum. The Louvre opened with great ceremony and celebration on August 10, 1793, a date that marked the one-year anniversary of the abolition of the monarchy; it was also only seven months after the execution of King Louis XVI, a public spectacle enacted at the Place de la Concorde, which was located just a few meters from the site of the new museum. At the time, France was also entering a period of unspeakable violence, known as the Reign of Terror, which

resulted in the public execution of about seventeen thousand innocent citizens and the death by other means of countless more.

The original planners working under the monarchy and their revolutionary successors were at least allied in an ambitious vision to create the foremost art museum the world had known. At the time of the opening—a joyous moment amid so much fear and violence—the new museum appeared to have realized these lofty goals; within a vast and magnificent space, the Grande Galerie presented 537 paintings and 124 sculptures of marble and bronze, all of unsurpassed quality and exceptional condition. From the day of its opening, and every day thereafter, the Louvre stood apart.

With the realization of its ambitious vision, the Louvre became a new symbol of the Enlightenment, at least as it was being interpreted by an unstable and violent revolutionary government. The new vision required the difficult task of bringing into alliance a program celebrating artistic excellence, staggering abundance, elite taste, and colonialist violence, on the one hand, while at the same time advocating a commitment to universal equality and unlimited public access, on the other. An alliance of such contradictory ideas proved to be uneasy and short-lived. Moreover, the original vision of the museum's founders was evolving from one dedicated to presenting the nation's cultural treasures to something more expansive that would soon require an aggressive program of new acquisitions.

In its early years, during the violent and unstable period of the revolution, and thereafter under the Directory and the sub-

sequent rule of Napoleon, the Louvre continued to prosper as its collections experienced extraordinary growth. The acquisition program driving this growth was based on a variety of colonialist practices, including forceful confiscation, coercive treaties, and military conquest, even as these practices were being abandoned elsewhere in Europe and recognized to be antithetical to Enlightenment values (at least with regard to relations between peer nations). At a time of profound social and political upheaval, the government and cultural leaders in France cynically exploited the moment to feed a nationalistic agenda of cultural hegemony, using political coercion and military force to confiscate, plunder, and pillage the cultural treasures of fellow European nations, one after another. The flow of artworks to Paris was both unprecedented and overwhelming, making it virtually impossible for museum staff to keep pace with the arrival of new objects. With the establishment of Napoleon as self-styled emperor of the republic, the museum was to enjoy the benefactions of its most ambitious patron, who memorialized his personal commitment to the enterprise by renaming the museum after himself.[17]

Although he seems to have had little real interest in art, Napoleon understood the political currency of high culture, and he envisioned himself as a champion of the Enlightenment—a designation for which he deserves slight praise, and certainly none in the area of cultural heritage. On military expeditions to Italy, Germany, the Netherlands, Austria, Greece, and Egypt, the French dictator arranged for teams of experts to accompany his armies—a rapacious version of "Monuments Men"—to find and obtain, by treaty, purchase, or plunder, whatever they wanted.

The resulting flow of cultural property to Paris was unprecedented in modern times, more closely resembling the actions in antiquity of Nebuchadnezzar or Titus. Amid dramatic and calamitous social change throughout France during the years of revolution and empire, the Louvre experienced mostly gain, firmly establishing itself as the leading art museum of the world.

In the aftermath of so much looting and coercive cultural appropriation, one consequence of enduring importance was the need, at the international level, for better "Enlightenment" thinking on questions of cultural property. Soon after Napoleon's defeat and abdication it became clear among European leaders that in order for France to rejoin the community of nations, the looted art on display in the Louvre and elsewhere throughout France would need to be returned to its rightful owners. Within a month of the French defeat at Waterloo, a movement was put in motion to secure the restitution of looted art. Although the French understood the magnitude of their defeat and the difficult road ahead, Vivant Denon, Napoleon's director of the Louvre, was not alone in his vehement opposition to restitution. The controversy over the disposition of plundered art raised several important questions, one of which concerned the very premise of the encyclopedic museum. For Denon, cultural looting was seen as a legitimate means of achieving his vision of a vast and magnificent encyclopedic museum, accessible to all for inspiration, learning, and enjoyment.[18] Within a single location, visitors could marvel at the greatest artistic achievements of all the cultures they so greatly admired. Denon had assiduously and consistently supported the predatory practices of his emperor and

even in defeat argued that restitution was nothing less than "spoliation" after so much had been achieved. There was widespread support for Denon's position, and to be sure there was universal praise for the quality of his museum. Still, there were others who identified the very real historical problem: something important was lost when works of art were stripped of their own history only to be placed within a constructed art-historical narrative.[19]

The task of negotiating a restitution agreement with the French government fell to the eminent Italian sculptor Antonio Canova, who in 1815 agreed to serve as papal emissary on a diplomatic mission to Paris. Working in an exceptionally fraught political environment, but bolstered by the support of leaders from the European nations that had suffered losses in the Napoleonic Wars, Canova was able to reach an agreement, but it was far from a resounding victory. The agreement stipulated that half of the works of art that had been taken from Italy—by conquest or forced contract—would be returned, while the rest would remain in France. This meant that about three hundred works of art, mostly paintings and sculpture of the highest quality and importance, would remain at the Louvre and various regional museums. This was an expected outcome, given the forces working against Canova, including Denon's steadfast and influential opposition to any restitution plan, and more important, the troubling fact that the French surrender had already been negotiated with no consideration of restitution. Other than diplomatic skill and moral high ground, Canova had been working with little real leverage.

During the two hundred years following the despotic rule of Napoleon, and in consequence of it, new laws and better prac-

tices governing cultural property have been established and have continued to evolve with time and circumstance. Although new legal and contractual questions continue to emerge, the moral issue was acknowledged long ago by the hero of this story, the Duke of Wellington, when he demanded the return of art "to the countries from which, contrary to the practice of civilized warfare, they had been torn during the disastrous period of the French Revolution and the tyranny of Buonaparte."[20] The recognition that cultural property should be governed by laws as much as by Enlightenment values is perhaps Napoleon's most enduring, if inadvertent, contribution to the field of museums.

3 the american experiment

The decades following the Napoleonic Wars were good ones for the museum movement. With increasing political stability in Europe, and the examples of the Capitoline, British Museum, and especially the Louvre, museums began to open in major cities across the continent. By midcentury the art museum had become an essential element of urban life, a marker of cultural sophistication, and a significant draw for tourism. From Stockholm to Dresden, Amsterdam, Berlin, and Madrid, the art museum had become a civic monument dedicated to advancing progressive social ideas while also serving to present a distinctive cultural identity, much like the magnificent treasures of the ancient Greek world that adorned the entryway to the sanctuary at Delphi.

The popularity of the Grand Tour and the progressive politics of Enlightenment-era governments inspired ambitious invest-

ment in public spaces to provide cultural enrichment, educational opportunity, restorative experiences, and entertainment. If the Capitoline had established an organizational template for the professional art museum, the Louvre offered the gold standard for quality, scale, and encyclopedic ambition, even if such a standard was thought to be unattainable by others. Despite widespread criticism for its collecting practices, the Louvre had become for many an exemplar of excellence and a cultural leader. Perhaps Vivant Denon had been right in arguing that the ends would eventually justify the means, even if it meant weathering a great deal of condemnation along the way.

For John Jay, a prominent New York attorney and grandson of the first U.S. Supreme Court chief justice, a visit to Paris in 1865 inspired an ambitious dream for his home city. During a Fourth of July celebration at the Pré Catalan, a restaurant in the Bois de Boulogne, Jay proposed the idea for a national institution and gallery of art, inviting other prominent New Yorkers who were present to join him in pursuing the lofty goal of creating a version of the Louvre back home.[1] Although inspired by the French example, and more generally by the larger movement taking place in cities across Europe, the American group was focused less on replicating the Louvre—which they recognized to be more or less out of reach—than on the more achievable goal of creating a museum that could educate and inspire the public, and, in so doing, provide a social good. As the Americans in Paris initiated plans for their own fledgling enterprise, the goal of establishing a museum filled with masterpieces to rival the venerable collections of Europe was not under consideration.

Among the many challenges before them, perhaps the greatest was the fact that the founders did not have any art. By contrast, the European institutions were all established from the outset with vast collections that had, in one way or the other, been assembled over long periods of time by people with vast resources and few limits on their collecting activities. And so The Met began with an ennobling and ambitious idea, even if it otherwise lacked what would be needed. With a heady sense of what was possible, The Met's founders were inspired by what they saw in Paris, even if they acknowledged that their own vision would inevitably be more modest, requiring flexibility, time, and determination. For Jay and the others, the objective was to build a cultural institution to serve the public good, which they saw as a necessary step in elevating New York to the top rank of cities around the world. Such a vision did not require an assembly of masterpieces, but it did require a large and diverse collection of objects that could instruct, inform, and inspire. Their goal was to create a "department of knowledge" rather than a collection of masterpieces.[2]

For The Met, the Museum of Fine Arts (MFA), Boston, and various other art museums being planned around the United States, the inspiring vision was a progressive one tied directly to the Enlightenment ideal: to build cultural institutions that would be in service to all, including the poor, uneducated, and dispossessed.[3] The American experiment was in essence an investment in democracy for a nation that was growing rapidly and becoming more diverse. The goal was to create spaces that served the larger public, providing access to education, beauty,

and cultural enrichment. Joseph C. Choate, one of The Met's founding trustees, outlined the primacy of this educational role in his remarks at the opening of the museum on April 13, 1870: "[The trustees] believed that the diffusion of a knowledge of art in its higher forms of beauty would tend directly to humanize, to educate and refine a practical and laborious people; . . . it might be possible in the progress of time to gather together a collection of works of merit, which should impart some knowledge of art and its history to a people who were yet to take almost their first steps in that department of knowledge."[4]

After the founding of The Met and the Boston MFA in 1870, within a few decades twenty-five new art museums had been built across the nation. Like The Met, the founding vision for the MFA and the others was to create something of genuine value for local communities: to use these new museums as a source of education and social enrichment to help lift people from poverty, ignorance, and despair. The museum movement in the United States was part of a powerful progressive vision that called for investment in public education, parks, and cultural institutions, all intended to advance the central values of the Enlightenment movement—which in the United States was in service to a growing, diverse population of immigrants who were helping to build the new nation. To be sure, the idea was inspired by the example of European institutions, but, as Joanne Pillsbury has argued, the American experiment also looked to other parts of the world for inspiration.[5] The American museum movement was from the outset based on wide public outreach and access. The museum was to be for everyone, a true extension of the democratic ideal

to provide for the well-being and growth of all individuals. Because of this core mission, American museums took on a new and distinct character that was based on a collective sense of ownership and mission. As Calvin Tomkins has written: "The mass public has always been the implicit justification for art museums in this country. Founded on the assumption that art was inseparable from education, American museums have addressed their primary appeal to the man in the street—rather than the artist, the scholar, or the connoisseur, who are nevertheless welcomed on their own terms—and it is for this reason that they have prospered and proliferated on a scale almost unknown in Europe."[6] For The Met, MFA, Philadelphia Museum of Art, and Art Institute of Chicago, among many others, the art museum formed one part of a large-scale civic investment in a democracy that was growing rapidly and becoming increasingly diverse.

In reflecting on the success of the Roman Empire, Edward Gibbon observed that, in contrast to the Greeks, who were steadfast nationalists, the Romans were a more pragmatic and inclusive people with regard to citizenship and social practices. For Gibbon, the Romans "sacrificed vanity to ambition" in expanding their empire and opening the path to citizenship for all who could contribute.[7] This had the dual benefit of strengthening communities—through a diversity of talent, background, and experience—while weakening motives for rebellion. Similarly, the American museum was to be an experiment in civics, providing an ambitious and diverse nation with access to an education informed by the art of a multitude of cultures, religious traditions, ethnicities, and races. If the European art museum

was intended to provide greater access to the cultural traditions of the wealthy aristocracies, the American version was both more pragmatic and progressive.

At The Met, the more modest "educational" vision of the founders was to expand under the leadership of J. P. Morgan, who served as president from 1904 to 1913. With the assistance of fellow trustees and administrators, The Met began to collect masterpieces, some through the acquisition of great collections such as that of Morgan himself, whose son gave The Met 6,500 works of art following his father's death in 1913. As the ambition and resources of the museum increased, so too did its collection and mission. Through extraordinary philanthropic support, the museum was able to build a collection in a matter of a few generations that rivaled those of the great European museums. To be sure, such success had not been contemplated by the museum's founders only a few decades earlier. Although various factors contributed to the rise of art collecting and philanthropy throughout the United States, an essential element was the creation of the War Revenue Act of 1917, which permitted income-tax deductions for charitable contributions, including works of art.[8] As Karl Meyer has argued, "The explosive growth of art museums in the United States could never have taken place without the silent, generous, and usually unacknowledged partnership of the American taxpayer."[9]

Due to its commitment to the public good and a democratic mission, and to the extraordinary philanthropic support that made it possible, the American museum movement represented a new direction that was more closely tied to the communities that

founded the institutions. Through greater independence in funding and governance, they were for the most part less obligated to city or state governments. The founders of The Met understood well the need for independence, stating in their official report that the museum should be "free alike from bungling government officials and from the control of a single individual."[10]

The American experiment advanced the Enlightenment idea further than it had gone in Europe, and it was met with great enthusiasm, resulting in more public engagement, greater philanthropy, remarkable growth, and more public accountability. With a deeper commitment to the local community, The Met and other American museums benefited from greater vitality, programmatic innovation, and public engagement. In good times and bad, the American museum has functioned as an essential part of its larger environment, which has provided both extraordinary opportunity and distinctive challenges, the solutions to which will define how these institutions and their missions will evolve.

Recent Challenges

Precisely because the American model was intended from the outset to be in service to the larger community, and fully accountable to it, there has been in recent years a renewed effort by many for substantive change in ways that align more closely with broader changes in society. The challenges ahead will include the need for progress in resolving specific questions about ownership of cultural property, diversity in programming, equity in

hiring and promotion of staff, and growth of collections. More generally, the museum of the future will need to realize increased levels of public access and inclusiveness, widespread financial accountability, and a genuine commitment to representative shared governance.

Throughout the United States, art museums continue to perform an essential function in shaping ideas, advancing learning, fostering community, and providing places of beauty and permanence. Yet, in order to respect their historic missions while meeting the needs of an ever-changing public in times of crisis and social change, museums have had to adapt to new challenges to ensure they remain programmatically meaningful, responsive to evolving ideas and tastes, and sustainable—financially, intellectually, and environmentally. This is a work in progress.

These challenges are proving to be formidable, with museums often not managing to be of service to all segments of the community. As we look to the future, museum leaders will be called upon to make a greater effort to ensure that the purpose and function of the museum is aligned with larger changes in society, but without losing sight of their core obligations to the preservation and study of the art in their care. This will inevitably require that they become more inclusive and welcoming for staff, trustees, and the public, while also encouraging innovation and spirited debate to ensure the museum functions as a serious forum for ideas. The years ahead will require museums to do more to protect cultural heritage and help to adjudicate claims between nations, communities, and peoples under changing legal circumstances, evolving societal norms, and uncertain polit-

ical environments. To address these issues, and others, museums need to reassess their place and their contributions to the public sphere they are dedicated to serving.

Whereas there is much to the American story that is laudable and well worth preserving, there is also a compelling basis for change. At this critical juncture, I think it is essential to explore the many ways in which museums make important and sometimes unique contributions to the communities they serve, and in so doing, help to demonstrate why they matter, perhaps especially at times of difficulty and urgent calls for progress.

Part II

Why the Museum Matters

4
a place of consequence

We all inhabit real and fictive spaces, which serve, for better or worse, as the setting for our daily lives, our memories, and our dreams. The places of greatest importance—where we live and work, rest and play, learn and find inspiration—become in the fullness of time interwoven into our cumulative life experiences and deepest sense of ourselves. Places form an essential part of each life story, helping to shape and provide context for who we become.

For a great many people, the art museum is a place of consequence because it offers—through its collections, exhibitions, and programs; its physical presence and accessibility; and its community—opportunities for exploration, personal enrichment, fellowship, inspiration, pleasure, and, with accumulated experience, memories. If the museum is often seen as a citadel of culture, it is also a sanctuary, providing a place of peace, sta-

bility, and permanence in a world where such things are in short supply. The most impactful art museums are a great deal more than the sum of their collections: they are places of beauty and consequence, thoughtfully designed and curated to provide experiences that, at their best, can transform us. As Nicholas Serota has written, museums allow us to "situate ourselves in space and in time through the vision of another creative being. Cumulatively, museums offer thousands of small and large epiphanies."[1]

To accomplish these lofty and transcendent objectives, curators, designers, conservators, and many others work collaboratively to align the formal elements of the museum—structure, design, appearance, collection, and basic functions—with its performance, which is the degree to which it transcends these constituent elements to excite us visually, inspire us intellectually, and move us emotionally. At their best, art museums take us to new places, allowing us to see the larger world differently than we otherwise would and, in turn, to learn something about ourselves. To be sure, this magical experience does not happen for every viewer on each visit, but it is the goal. Of course, the specific experience an individual might have inevitably depends on a constellation of factors that are themselves interconnected and mutable with time and circumstance. These include the formal properties of the building; its location and particular setting; the collection on view and the manner of its presentation; the particular circumstances of the visit; the quality of the experience; and the memories it might evoke. Although there is no way to make all of this right for every visitor at all times, it is the mission and business of the museum staff to try.

In my years at The Met, I have been privileged to hear from many visitors, friends, and colleagues about the special relationship they enjoy with the museum, which more often than not extends back to their formative years. The bond between museums and their people is often an enduring one, sustained with effort and care across long expanses of time; early visits are remembered for how they helped to shape specific interests, tastes, or even an emerging sense of identity. In exploring the richness and diversity of cultures across vast expanses of human history, especially at moments when we are especially alert to learning about them, we discover new and more resonant versions of ourselves. For many, the museum provides an ideal setting for our own learning and empathetic engagement with other times and cultures; this helps us form our own distinctive identities, and in so doing, become inextricably connected to the museum itself.

Buildings

The concept of time is an important and multifaceted component of the museum idea. As works of architecture, the various spaces constituting the museum are themselves markers of time, reflecting the moment of their creation as much as the ideas that inspired them. At The Met, with ever-expanding collections spanning more than five thousand years, the museum structure is both an architectural palimpsest, revealing the building's history in multiple layers, and an organic entity that continues to grow and evolve. As of this writing, The Met consists of an accretion of twenty-one connected buildings, several dozen wings,

and hundreds of galleries, collectively representing a multitude of styles that have been knit together—with varying levels of success—into a single structure from one campaign to the next over a period of nearly 150 years. Some design elements remain iconic, such as the beaux-arts Fifth Avenue façade and Great Hall by Richard Morris Hunt and the glazed pavilion enclosing the Temple of Dendur by Kevin Roche. Other design elements have, in the course of time, been subsumed by subsequent building campaigns, detectable now only if one knows where to look for them. One prominent casualty of expansion is the original Gothic Revival building of 1879 designed by Calvert Vaux and Jacob Wrey Mould, an airless, gloomy box that fell into disfavor soon after its completion. Traces of the original building are visible today in various adjacencies, as, for example, in the structure's west-facing exterior façade that now adjoins to the Lehman Wing. Throughout the building, these spaces reflect the particular objectives and distinctive circumstances of their time as much as they reflect our own. As Kathleen Curran has observed, The Met was a great recycler of old parts, which led one critic to complain that the museum's plan was a "chaotic labyrinth where you need a chart and compass to get up or down stairs."[2]

As a living building, constantly evolving in response to new ideas, opportunities, and challenges, a museum is not everywhere a well-integrated masterpiece of design but rather something of a perpetual work in progress. Just as the disparate and evolving collections of an encyclopedic museum represent a diversity of styles and subject matter, so too does the architectural space contain a synthesis of disparate times, or at least a gathering of distinct

moments in a shared space. An interesting case in point can be found at the National Gallery in Washington, D.C., where the neoclassical West Building, designed by John Russell Pope in the 1930s, is adjacent to the modernist East Building, designed by I. M. Pei in the 1970s. If the museum's ambition is to allow the art of all times to coexist, so too does it seek to reach people within this space throughout the times of their lives. With regard to collections, spaces, and people, central elements of the museum idea are to encompass all of time and preserve individual moments.

In the fullness of time, and with ongoing engagement, the museum can become an essential part of a person's core experiences and identity. I think this is what Alain de Botton was referencing when he wrote, "What we seek, at the deepest level, is inwardly to resemble, rather than physically to possess, the objects and places that touch us through their beauty."[3] For those who care most deeply, each visit is a form of pilgrimage, reaffirming something of personal consequence while also expanding understanding and a particular frame of reference. Mastery of the intricacies of the place becomes a point of pride. This is why so many people refer to beloved museums as "theirs." What is most remarkable about this process is how distinctive the museum becomes for each person—a bespoke version of the greater institution reflecting specific tastes, rituals, and experiences. I know of no other kind of public space that can do this for people in quite the same way.

The relationship people develop with their museums tends to be stable, which offers the comfort of predictability and a sense of permanence in a rapidly changing world. Because of the personal

importance the museum holds for such people, they tend to take a deep interest in how these institutions are run and when they are subject to change. After having life-enhancing experiences in a particular setting, people often want to preserve those aspects of the place that remind them of their own pleasure and personal transformation. We seek to relive those powerful and positive experiences each time we visit and therefore want to limit the ways in which "our" museum is altered. In my experience, and this is entirely a good thing, museums are watched very closely when we make changes.

My own encounters with the Louvre offer a useful case in point. My earliest visits, which predated the massive interventions of Pei in the late 1980s, were exciting and memorable explorations, but so too were they arduous. At the time, the vast collections were displayed throughout what was then a tired old palace within a labyrinth of difficult-to-find galleries. With time and experience I was able to achieve some level of mastery over the complex and idiosyncratic spaces, which provided for me a sense of satisfaction, even if each visit required long waits at any one of the myriad palace entrances open on that particular day. As I saw it then, access to such a reward had to be earned. Although the collections were beyond compare, the museum experience was something of an ordeal.

I was not alone among devoted visitors to have found Pei's ultramodernist design for the Grand Louvre project, with its glazed pyramids blighting the Cour Napoléon, to be aberrational. The controversy was, from the outset, labeled by critics and the public the Battle of the Pyramid.[4] Perhaps because I had mastered the

intricacies of what had become "my" museum, I was unmoved by the plan to refashion the Louvre into a welcoming and efficient center for more casual visitors. Opposed though I initially was to the Pei design, I was soon captivated by its visual brilliance and obvious functional advantage. The new Louvre had become a better and more welcoming museum for everyone, including those like myself who had grown accustomed to the old model. I was especially grateful for the ready access to all of the museum from a single dazzling and highly accessible point of entry. Getting in and around would no longer be the main focus of my effort. I learned from this experience that when form and function align so well, the sense of beauty increases with the performance of the space.[5] Like the once-controversial wrought-iron tower designed by Gustave Eiffel, the Grand Louvre is now a beloved landmark in Paris.

Like The Met and the Louvre, most historic or encyclopedic museums are complex structures with their own histories. Because the aesthetics and functioning of the building are so important to the overall experience, most major museums inevitably and appropriately evolve with the times, even if they also present an image of permanence and stability. One of the most imaginative and compelling recent renovations to a historical museum is the Neues (New) Museum in Berlin. Opened in 1855, the Neues was built to hold the expanding collections of the rapidly growing Königliches, or Altes (Old) Museum, which had been dedicated in 1830 as the first cultural commission on what was to become Museum Island, a *Kulturzentrum* dedicated to showcasing art and science. The Altes, which was commissioned

to house art that had been repatriated as part of the settlement of the Napoleonic Wars, soon required a new structure to accommodate a growing collection of ancient art. Friedrich August Stüler, architect for the Neues, created a museum in the neoclassical style, replete with such classicizing elements as a life-size replica of the Porch of the Caryatids from the Athenian Acropolis, but he also employed modern building technologies, including a steam engine to facilitate construction and steel frames for the stairways. The building was, in its design and function, a monument to the ideals and spirit of optimism of the Enlightenment. Like much of the cultural property on Museum Island, the Neues was badly damaged during the Allied bombing of Berlin in World War II. But unlike other damaged museums in postwar Berlin, the Neues was neither rebuilt nor repaired; it was left exposed to the elements, where it was slowly dissolving into ruin. The German Democratic Republic eventually developed a master plan to rebuild the rest of Museum Island, but the Neues was left to deteriorate as a haunting symbol of a tragic and terrible time.

It was only in 1997, more than a half century after the museum had been destroyed, that the reunified German government initiated a project to transform the Neues from the lamentable relic it had become into a functioning museum once again. The commission was awarded to British architect David Chipperfield, who sought in his innovative design to balance three central elements: Stüler's neoclassical building; the ruinous legacy of the war; and more recent developments in contemporary ar-

chitecture. What is remarkable here—and wholly unexpected among more traditional museum renovations—was Chipperfield's desire to create something new that nonetheless embraced a conflicted and difficult history. This would not be a renovation that simply recalled, albeit with modern materials, the golden age of the original building. For Chipperfield, the material sources for his design would include in equal measure Stüler's building and the ruin that it had become. This approach was, at the time Chipperfield began his work, a significant innovation for such historical renovation projects, most of which sought to erase the destructive evidence of time and circumstance in favor of fidelity to the original idea. Chipperfield's vision for the Neues was particularly appropriate for a nation with such a steadfast commitment to confronting its ghastly history under National Socialism. From the moment of its rededication in 2009, the Chipperfield renovation was lauded as a significant and visionary achievement, a "spectacular reconstruction that has left visible the traces of ruination in the very substance of the building," as Kerstin Barndt wrote in 2011.[6]

As we experience it today, the Neues offers a multilayered vision of the past, what Barndt called "temporal pluralism" for how the elements of the building—architecture, interior design, and the collection itself—contribute to careful and deliberate presentation of mythical, historical, and art-historical time.[7] At the Neues this includes, with equal prominence, the inspiring nineteenth-century monument, the devastated ruin of a century later, and the present realization under a reunified Germany. For

an institution dedicated to understanding the continuities of time and cultural progress, the Neues embraces its history—the good with the bad—and in so doing offers a new vision for its future.

I remember well my first visit to the Neues, which was mostly a pilgrimage to see its greatest treasure, the magisterial bust of the Egyptian queen Nefertiti. Arriving at the East Entrance, I passed through the heavily repaired classical arcade of Doric columns and then beneath the pedimented façade, noticing throughout evidence of war-related damage and other losses, as well as areas of modern replacement. Within the vestibule, I encountered a large, open area dominated by the main staircase, a Chipperfield redesign made of white cement and Saxonian marble chips intended to reflect Stüler's lost original without imitating it. Climbing to the second floor, I turned to my right to enter a rectangular and surprisingly tall skylit gallery constructed of aged recycled brick. The space introduces the museum's extraordinary collection of ancient Egyptian sculpture: pristine figures interspersed with beautiful fragments, displayed on axis under a diffuse light. Once I reached the far side of the room—having experienced in just a few moments the sculptural achievements of millennia—I could see before me the corner gallery where Nefertiti, lit only from above, presides at the center of her darkened audience hall. The painted walls of the domed gallery evoke an ancient palace, or at least a nineteenth-century version of such a space. The small but stunning object holds the room and the gaze of all who enter.

In the few moments it takes to pass from the East Entrance into this sublime space, a profound sense of history becomes palpa-

ble, encompassing the bold vision of the museum's founders, the devastations that were to follow, and especially the epic journey of Nefertiti herself across vast expanses of time and space, from ancient Amarna to modern Berlin. To visit Nefertiti within this redolent place is to feel a sense of connectedness—perhaps spiritual in its intensity—for all of us embarked on our own journeys, from wherever we began to wherever we are headed. This is what museums can do for us.

Interior Spaces

Within the architecture of the building itself, the creation of distinctive galleries and exhibition spaces is an essential part of what museums do to inform or guide the experience of viewing art. The galleries dedicated to special exhibitions, which generally change with each new installation, constitute a special opportunity to enhance the quality and distinctiveness of the visitor's experience. At large institutions such as The Met, considerable resources are devoted to maintaining an active schedule of rotating exhibitions that generally highlight some combination of works from the permanent collection and loans from elsewhere. For each special exhibition, the design of the space is an essential element in creating an engaging experience—visually, intellectually, and viscerally—for the visitor.

For more than a half century, since the innovative programs developed at The Met under Director Thomas Hoving, special exhibitions have become a prominent and resource-intensive part of programming in most art museums. One of the earliest and

most memorable of these special exhibitions, which occurred prior to the Hoving years, was surely the special visit of the *Mona Lisa*, which drew nearly one million visitors to the Fifth Avenue museum during a three-week period in 1962. Since Leonardo da Vinci's masterpiece was long regarded as the most famous painting in the world—an unprecedented draw even for New Yorkers—the actual exhibition required little more than a serviceable gallery with proper lighting and manageable access for crowds of visitors. The painting was the show, but the essential message was clear: the public would turn out in large numbers to see something new and different. Just two years later, in 1964, Michelangelo's *Pietà* was offered on loan from the Vatican for the New York World's Fair in Flushing Meadows. Although this was not an installation within an art museum, and there were a great many other attractions at the fair, Michelangelo's sublime masterpiece was the highlight for most who visited.

During the Hoving years, ambitious special exhibitions became a means to create distinctive events that would generate new levels of interest from the public and substantially increase audiences. Most "blockbuster" exhibitions, to use a phrase coined in the Hoving era, are highly ambitious projects requiring an innovative and exciting programmatic vision, special loan agreements for objects that are often difficult to borrow, carefully designed spaces that evoke a particular setting or context, and significant resources to make it happen. The objective for such exhibitions is to provide an immersive experience for the visitor, not unlike what happens for audiences in the theater. The earliest of these major special exhibitions, and in many ways a touch-

stone for all that were to follow, was the *Treasures of Tutankhamun,* a loan show organized by The Met between 1976 and 1979, featuring fifty-three objects that had created a global sensation when they were excavated in the 1920s from the young pharaoh's tomb in Egypt's Valley of the Kings. Hoving's achievement was in persuading the Egyptian government to lend these objects for the benefit of audiences that otherwise would never have the chance to see them. The museum's challenge was in creating an experience that would justify the risk and expense. The work of a major exhibition includes substantial investment to design and build spaces, transport and conserve precious and fragile works of art, produce new scholarship and didactic materials, and present a narrative to engage diverse and wide-ranging audiences.

Since the Tutankhamun exhibition, The Met has mounted several hundred shows of comparable ambition, each requiring specially designed spaces. In a typical year, The Met presents twelve to fifteen major exhibitions, along with several dozen on a smaller scale. Since the Hoving era, The Met has maintained a department dedicated to management and oversight of the special exhibition program, which engages several hundred members of the professional staff, from curators and conservators to exhibition designers, art handlers, and casework fabricators. Over the years, both at The Met and at museums around the world, we have learned that large and increasingly diverse audiences are drawn to museums for the special exhibitions and events that provide new and distinctive immersive experiences within spaces that are familiar to many of them. For these visitors, the context and gallery design contribute fundamentally

to the overall experience, informing in fundamental ways their encounter with the art. At major museums like The Met, the special exhibitions program is an important attraction for regular visitors but also for tourists and those with an interest in the particular topic.

For the most part, the special exhibition galleries at The Met are vast open spaces, veritable "white boxes" that are transformed for each show. Think of a warehouse or large retail store without inventory. Members of the exhibition team—curators, conservators, designers, editors, art handlers, technicians, and tradespeople—all work together to execute a vision to transform this space into something inviting and immersive, which facilitates careful looking at the art while also setting a context for critical thinking and learning.

In recent years, one of the most popular special exhibitions at The Met was *Michelangelo: Divine Draftsman and Designer,* which ran from 2017 to 2018 and was curated by Carmen Bambach, the Marica F. and Jan T. Vilcek Curator in the Department of Drawings and Prints. Although the show was dedicated to exploring the full range of Michelangelo's artistry, the majority of the works in the show were small-scale drawings. The greatest challenge for Bambach and the design team was to capture the sense of monumentality that is at the center of Michelangelo's art in all of its forms, from his massive sculptural works and large-scale wall paintings to his small but powerful drawings. Bambach wanted visitors to experience the artist as a creative force with a monumental vision but also as a human being. For

Bambach, conveying a sense of Michelangelo's human dimension, along with his artistic brilliance, helped to make the visitor's experience more meaningful and accessible. "Visuality is what matters most. It is what enables us to forget, at least for a few moments, so much about ourselves, so that we can learn more about this remarkable artist as a great master and as a person who lived in a particular time and place. In so doing, as we move through the exhibition, we try to provide a context for a transformational experience. Our goal is, in some small way, to change each visitor through the experience of seeing as they haven't before."[8]

To convey this sense of monumentality within the white box of the museum's special exhibition galleries, Bambach and the design team chose to emphasize the large scale of the spaces without overly designing them. Several of the galleries in the show, which featured relatively small drawings, had high ceilings and large open spaces between the objects in order to convey the sense of scale and monumentality present in the images themselves. By contrast, in one of the largest galleries, the team employed a different approach to evoke a sense of monumentality and the human scale of Michelangelo's achievement by re-creating the frescoed ceiling of the Sistine Chapel, complete with a scaffold to show how the artist actually undertook this daunting and debilitating commission. Such a theatrical design for a complex, scholarly exhibition is not without risk, but Bambach was committed to the idea that museums are laboratories for creativity, just as they are for scholarship. She wanted the visitor to experience a "different kind of learning that is not possible in a book or

a classroom, that allows for deeper engagement with the art and the person who created it."[9] For Bambach, this is what makes museums places of consequence.

Exhibition design inevitably plays a crucial role in shaping the desired experience and helping to convey the central ideas. For example, in a recent exhibition at The Met on the complex and sensitive topic of slavery and race in nineteenth-century Europe, Elyse Nelson, assistant curator of European sculpture, who co-curated the show, wanted visitors to understand that the objects can be both beautiful and troubling. This means that we can take pleasure in the beauty of such works as Jean-Baptiste Carpeaux's *Why Born Enslaved!* while also recognizing that the motives of the artist might not be aligned with the progressive values they ostensibly champion. The sculpture portrays an enslaved woman, with a defiant gaze and exposed breast, straining against the ropes that bind her. Nelson has argued that Carpeaux has created an image of "aestheticized violence—the transformation of human carnage into erotically charged drama." For Nelson, "Exhibition design can help express these complex and contradictory ideas in various ways, by encouraging visitors to slow down to see specific details or arrangements, by disrupting the traditional subject-object relationship, by refusing a linear narrative path in favor of a thematic one, and by drawing the visitor's awareness to their own gaze."[10]

In addition to the immersive experience enabled by "white box" spaces, other kinds of viewing experiences are possible in galleries that are not isolated or readily transformed. At The Met we had a special opportunity to experiment with new approaches

to exhibition planning when in 2015 we reached an agreement to use the former Whitney Museum of American Art on Madison Avenue. Our plan was to transform the Bauhaus-trained Marcel Breuer's modernist masterpiece into a Met space focusing on special exhibitions of modern and contemporary art, and particularly in ways that connected to our encyclopedic collections. The idea was to present more innovative and edgy exhibitions than is customary for The Met within this iconic building. In the four years that we occupied the "Met Breuer" we presented more than two dozen ambitious and distinct special exhibitions. Because this formidable building is such an insistent and powerful presence, each of these exhibitions was designed to integrate aspects of the architecture into the overall design.

The assignment for leading the Breuer project was given to Sheena Wagstaff, the former Leonard A. Lauder Chairman of the Department of Modern and Contemporary Art. For Wagstaff, the project offered a special opportunity for The Met to engage in a new kind of programming, one that placed our permanent collections and historical materials in service of new questions and in more innovative ways. For Wagstaff, the Breuer building was itself a central element in her project. As she explained to me: "The Breuer must be taken on its own terms, as a powerful and compelling modernist statement and, actually, a superb space for viewing art."[11] Wagstaff reflected on the complexity and ambivalence of the building's design as it related to its setting in New York. As an inverted ziggurat made of reinforced concrete and gray granite, the building has been characterized as a monolithic fortress, surrounded by a moat and protected by a simulated

drawbridge intended to isolate the museum from the noise and energy of the surrounding city. For Wagstaff, such an interpretation misreads the building's design and intended purpose, which she sees as a formal commitment to embracing that energy. As Wagstaff observed, the moat is actually a sunken garden and the entrance a concrete gateway spanning the garden, effectively linking the museum to the city.[12] Of course, it is possible that Breuer was alert to both interpretations of his controversial design, allowing the bustling urban setting to be either a distraction to be minimized or an enhancement to be embraced. Over the years, both approaches have been used within the building, depending on the particular vision at the time.

The brilliance of Breuer's imposing design lies in its subtlety and flexibility: it is both an iconic architectural landmark and a remarkably effective space for viewing art. My own experience of the Met Breuer was initially quite negative, just as had been my response to the I. M. Pei redesign of the Louvre. As an occasional visitor over the years prior to my joining The Met, I was generally disdainful of the massive block of granite and concrete that disrupted the chic Madison Avenue streetscape. When I found myself responsible for overseeing the Met Breuer and actively involved in programming it, I came to see its superlative qualities as an art museum and found myself agreeing with the assessment of architecture critic Victoria Newhouse, who called the museum one of the most successfully designed in the world.[13]

The concrete, granite, and oiled bronze interior of the galleries, along with the bluestone floors, presented various options for the display of art within well-lit, generously proportioned spaces but

never without accepting the strong presence of the building itself. For each of the exhibitions The Met installed at the Breuer, the building—and by extension the architect—was an important participant.

The Frick Collection, which succeeded The Met as tenant of the Breuer during the period the Fifth Avenue mansion was closed for renovation, also chose to embrace—rather than conceal—the building's modernist design as a central element of its installation. The Frick Madison, which served as a temporary exhibition space for highlights from the permanent collection, included early modern paintings, sculpture, and decorative arts, all of which were more naturally suited to their permanent home within the sumptuous and decorous interior of the Frick's Fifth Avenue mansion. To install the Frick masterpieces within such a hard-edged modernist building was not without risk, especially if the overarching vision was to embrace the space on its own terms rather than attempt to disguise or erase it.

In my view, and that of many colleagues and critics, the Frick team realized an entirely new, and wholly sympathetic, space for viewing their collection. The new installation offered a visually powerful and highly complementary synthesis of art and architecture, made possible because of the distinctiveness of the Breuer design. The contrast between the hard, gray surfaces of the Breuer building and the warm, sumptuous interiors of the Frick mansion could not be more stark, but the new setting foregrounded the Frick masterpieces in well-lit, purpose-built galleries, ideal for viewing the works of art as independent objects rather than as part of a larger decorative program. In commenting

on the dramatic presentation of Giovanni Bellini's masterpiece, *St. Francis in the Desert, New York Times* art critic Jason Farago remarked on the powerful and startling synergy between art and architecture: "Now the Bellini has been isolated in a room of its own, in a gallery bare as a monastic cell. Light falls, from the same angle as in the painting, through a small Breuer window that the Whitney and Met often obscured. As I sat in that empty room, the cold February sun streaming in, it felt like a space worth a pilgrimage." Farago went on to draw the connection between the Breuer space and the Frick vision: "In the Renaissance and in the modern age, in the Bellini and the Breuer, sometimes aestheticism is the path to the sublime."[14]

Even for those who long admired the Frick mansion as the ideal backdrop for the collection, the Breuer setting offered something intriguing and important. James Panero, art critic for the *New Criterion,* is an ardent fan of the mansion as a superb setting for viewing the Frick Collection, even if it has "gone against every modern museum trend of pasteurized, homogenized white-cube walls." Nonetheless, Panero was full of praise for the Breuer installation, which "offers us an opportunity to have a direct engagement with art . . . in an achingly spare, intimately thought-out presentation."[15] For Panero, as for Farago, the place—the setting, the light, the sheer physicality of the space—is a central element in creating the experience.

The museum, at its best, allows visitors to see things in new ways that might challenge, provide comfort, inspire, or entertain. The goal is for the place to contribute to, or even provoke, new ways of seeing and thinking. In embracing the Breuer on its own

terms, the Frick team was able to provide viewers with a unique opportunity to see the greatest works of their collection in a new way, and in so doing, provide visitors with a sublime experience. For the Frick, as for The Met and the Whitney before, the distinctive qualities of a superb art museum help to shape the visitor's experience and fulfill a distinctive vision.

Ethical Spaces

As carefully designed, welcoming institutions that are built to last, museums allow us to have conversations with ourselves, in real time and across the years. With each visit, we are able to see new things and to learn, to observe the familiar with fresh eyes or take an interest in the distinctive and different within settings that are beautiful, comfortable, and safe. Over the years, our relationship with the place and the objects it contains becomes deeper and more meaningful. Learning and deep engagement work in a complementary way for occasional visitors, primarily through the experience of exhibitions, collections, and programs.

It is for these reasons above all that museums are, to borrow a phrase coined by Karsten Harries, ethical works of architecture.[16] For Harries, the ethical function of architecture is to seek a common ethos, transcending its formal and functional properties to help us understand our place in the world, to activate shared values, and, along the way, to inspire the best in us. Such an approach is to be distinguished from a purely aesthetic one, which more narrowly joins an aesthetic component to a functional space. For Harries and his followers, ethical buildings are

investments in the future, holding the promise of progress and better days. The American art museum is, at its best, a powerful social experiment: a place that aims to represent the best version of ourselves, created by our own effort, enabled through collaboration, and sustained with our own resources. If we apply such a framework to Harries's concept, museums are inevitably, and perhaps quintessentially—by virtue of mission, purpose, use, and impact—ethical buildings; they are places of consequence both to individuals and society at large. In reflecting on this concept, critic Paul Goldberger wrote, "When architecture is both beautiful and ethical, it invites belief."[17] The mission of the museum is to allow us to experience beauty and wonder, to learn, and to reflect on our place in the world.

The museum is a place of consequence because of its determination to reflect us at our best—collections, spaces, ideas, and community—even as we recognize that it is always imperfect. An ethical approach to the museum is to recognize that the institution and place matter in shaping lives and values, while also acknowledging that it must be a work in progress. At its core, the museum idea is about progress, about learning from our past, valuing beauty and truth, understanding our place in the world, and, most important, about where we go from here.

5
a forum for ideas

If the museum has always been experienced as a place of beauty and permanence—something like a sanctuary—it also functions (or aspires to) as a place where ideas are discussed, debated, and critiqued. The challenge in realizing such an objective is that we live in a world that does not value productive disagreement or strenuous debate. If the museum is seen as a sanctuary, it realizes its societal mission most effectively by serving also as an arena for serious engagement in the realm of culture and ideas. Yet, as our society devalues constructive discourse—and, on occasion, punishes or ostracizes those who take unpopular views—curators and museum leaders have become more risk averse in developing exhibitions and programs that might generate controversy, and they are for the most part opposed to deliberate provocation. Social media and other digital discourse place greater emphasis on compliance and alignment as

opposed to the risks of freedom of expression. The consequences of highly visible controversy can be catastrophic for the program creators, institutional leaders, and even the museum itself. One result, and it bodes poorly for the future, is the continued march toward market-tested, commercially viable programming and away from art and ideas that truly challenge us or, even worse, provoke conflict or debate.

At the same time, museums have become places that are expected to serve as engines of social progress where equity, openness, and access are assured for all with an interest in the institution's mission. Of course, it is difficult, if not impossible, to imagine that social justice, unfettered creativity, or provocative discourse can thrive in an environment dominated either by unyielding stalwarts of the past or the practitioners of cancel culture. Like colleges and universities, the museum is at risk of paralysis or at least mediocrity and further commercialization. The challenge ahead is for museum leaders and their boards to develop more imaginative, and probably courageous, approaches to engaging the diverse audiences they are attracting, while focusing on how to provide safe places where ideas can live and genuine learning can take place.

Regardless of the current debate, it is inevitably the case that the museum will continue to function as an important public sphere, serving the needs of individuals and the larger community for public discourse and shared learning. For the museum to serve its educational and scholarly mission most effectively—to be truly a vibrant public sphere—it will be essential to respect new thinking, innovation, discovery, and

meaningful discourse. This will not happen without care and deliberate effort, and will almost certainly inflict some degree of discomfort.

Rules of Engagement

Philosopher Jürgen Habermas was the first to investigate the history and role of the public sphere as a space for community discourse, an idea he credited to seventeenth- and eighteenth-century Enlightenment thinkers.[1] For the free exchange of ideas truly to thrive among what Habermas called the "economically unproductive and politically functionless urban aristocrats," by which he meant the intellectually engaged citizenry, there needed to be new spaces created where all who were interested could assemble, regardless of wealth, power, or social position.[2] The earliest of these public spaces in the modern era—the ancient Greek and Roman worlds had an abundance of them—were simple coffeehouses, of which there were three thousand in London alone by the first decade of the eighteenth century.[3] With the passing of time and the benefit of progressive societal change, the public sphere came to be recognized more formally for its civic purpose, and the role fell increasingly to public institutions such as universities and museums. By the end of the nineteenth century, museums such as The Met, the Louvre, the British Museum, and the Victoria and Albert had become centers for scholarship and cultural discourse as much as they were for the display of their collections.

Acknowledging that public spaces could vary with regard

to size and composition, style of proceeding, or specific topics, Habermas nonetheless identified three criteria that all shared.[4] The first is that there be no hierarchy of discussants: expertise, knowledge, and argument must prevail over personal position and status. In asserting the idea of the parity of common humanity, Habermas observed that "the authority of the better argument could assert itself against that of social hierarchy."[5]

The second condition was that the "domain of common concern" would not be restricted or otherwise regulated. Topics for discussion and debate would be generally accessible to all who were participating. This meant that difficult or controversial subjects would not be off-limits, even if doing so presented the possibility of giving personal offense. Since participation in the discussion was understood to be voluntary, each person maintained the right to engage or withdraw at any time. Indeed, strong differences of opinion were understood by Enlightenment thinkers to be the most effective means of advancing knowledge. Only through rigorous testing and debate in an open competition, they argued, would the ideas most able to withstand criticism be able to prevail. John Stuart Mill, John Locke, and many other Enlightenment thinkers acknowledged that individuals carried their own biases and prejudices, which they recognized to be part of the human condition, but they believed that an open competition of ideas provided greatest access to the truth. As Mill argued: "To give any one set of partialities, passions, and prejudices, absolute power, without counterbalance from partialities, passions, and prejudices of a different sort, is the way to render the correction of any of those imperfections hopeless."[6] Mill's concept that

the clash of differing opinions is a powerful means of generating truth remains a central premise in the justification for free and open inquiry, even if in consequence it can be hurtful to individuals or groups. More recently, in his book *Kindly Inquisitors,* Jonathan Rauch argued for the collective benefit of a marketplace of ideas. He wrote: "An enlightened, and efficient, intellectual regime lets a million prejudices bloom, including hateful ones. It avoids any attempt to stamp out prejudice, because stamping out prejudice inevitably means making everybody share the *same* prejudice, and thus killing science. Rather, it pits people's prejudices against each other. Then it sits back and watches knowledge evolve."[7] To silence voices that are objectionable or otherwise in the minority is to diminish the quality of public discourse and, ultimately, to deter progress toward greater understanding. It is also an excellent way to cultivate second-rate ideas.

The third criteria for Habermas was that the participants would be inclusive of the "public of all private people," meaning that all who were interested would be welcome to participate. To hold that all were equally welcome was based on the laudable conviction of a shared humanity, recognizing, while making such a claim, that not all voices were equally informed, eloquent, or persuasive. The competition for ideas should be open to all, but the merits of substantive knowledge and reasoned argument must be allowed to prevail as determined through productive, open discourse.

The three conditions outlined by Habermas—no hierarchy of opinion, no topics off-limits, and no restrictions on who gets to participate—do not in the present environment go far enough to

ensure that the public sphere will be able to function as a productive forum for ideas. Whether it takes place within a museum, university, or coffee shop, public discourse will also need a few additional rules of engagement if it is to have a chance for survival in the difficult years ahead. Three such rules come to mind, each of which may well have been self-evident at the time of David Hume and Mill, but regrettably this is no longer the case.

The first rule is to distinguish between critique for an idea, argument, or its underlying rationale, on the one hand, from the individual proposing it, on the other. Good ideas can come from egregious people and sometimes even appear to be bad ideas until fully tested. Equally, of course, good people are capable of generating very bad ideas, and sometimes do so with disconcerting self-righteousness. Put differently, to accept our common humanity is to acknowledge that it is the idea that deserves respect regardless of who proposes it, and which must include serious interrogation; but neither disparagement nor special pleading should be applied to the person proposing it. It is the idea that matters in the realm of liberal inquiry, and everyone benefits if the available pool of ideas is unconstrained by any kind of censorship or litmus testing.

Whether one believes that the term "cancel culture" represents a real phenomenon or is merely a polarizing epithet, it is difficult to deny that the current practice of social and professional ostracism, accelerated by an abundance of online platforms, has had a chilling effect on free and open discourse and that it imposes grave consequences on those who have fallen victim to it.[8] Rauch, who has devoted much of his career to defending the impor-

tance of free speech, has argued with reference to our more recent challenges that there is a crucial distinction to be made between criticism and what we now call canceling. For Rauch, criticism is expressing a rational argument with the goal of persuading opinion, either in the public or private realm. Criticism allows for the possibility that debate and disagreement can be purposeful in generating knowledge and advancing the search for truth. By contrast, Rauch has argued that canceling is a form of social murder because it aims to ostracize, deplatform, and destroy the careers and livelihoods of real individuals. More specifically, Rauch has argued that canceling is not about critical discourse at all. To the contrary, it is about isolating or intimidating an ideological opponent with punitive intent, generally through some kind of organized campaign of intimidation directed against individuals rather than their ideas.[9] The result of such a campaign can have devastating consequences for even well-meaning people who wander into forbidden territory—whether knowingly or not—and without regard to the larger record of their accomplishments or character. Most important and inevitably, it also has a chilling effect on everyone else.

Although pressure on free and open debate within the cultural sphere had been growing for many years, the national protest movement that arose in the spring and summer of 2020 following the murder of George Floyd led to ever heightened vigilance around what constitutes acceptable speech. Among recent examples from the time, we might consider the case of Gary Garrels, former senior curator of painting and sculpture at the San Francisco Museum of Modern Art (SFMOMA), who, it should

be said, had a strong record of collecting the work of artists from underrepresented groups during his decades-long tenure. In the fateful summer of 2020, in the course of a Zoom meeting with colleagues, Garrels made reference to his collecting plans, saying, in part, that "we will still continue to collect white artists." Later, when his remarks became public, he defended his position by arguing that not to collect white artists was a form of "reverse discrimination," which led to a massive backlash within the museum and then more broadly on social media and the press. Presumably without foresight or malicious intent, Garrels had used a phrase with a difficult and polarizing history, going back to the 1960s when it had come to be associated with racist responses to voting rights legislation. The response was swift and overwhelming. Within a matter of days, leadership at SFMOMA received a public petition, signed by hundreds, calling for Garrels's removal from the museum for his "violent and hurtful" use of language. The petition was soon followed in succession by letters from SFMOMA store employees and members of the curatorial division, each demanding action. Within a week, following twenty-seven years of service at SFMOMA, Garrels tendered his resignation. He offered a heartfelt apology for his remarks and said that he was leaving so as not to disrupt progress in the ongoing work to build a more inclusive and diverse museum.[10] If this long-standing curator had been able to clarify the meaning of his words, and if his attackers had taken a moment to reflect on his genuine commitment to the same objectives they were pursuing, he might not have had to sacrifice his career for one intemperate remark. None of this is to diminish the very real

legacy of pernicious racist behavior that has been permitted to hide behind the use of ostensibly neutral phrases such as "reverse discrimination."

The second rule of engagement, which relates to the content of the debate, is no less important for ensuring that the greatest value of public discourse be realized. This concerns the primacy of evidence-driven inquiry over personal experience in matters of legitimate public concern. The argument for objectivity and public access to evidence was well presented more than a century ago by Charles Sanders Peirce, one of the United States' leading, if still relatively unknown, philosophers and public intellectuals. He wrote: "Unless truth be recognized as *public*—as that of which *any* person would come to be convinced if he carried his inquiry, his sincere search for immovable belief, far enough—then there will be nothing to prevent each one of us from adopting an utterly futile belief of his own which all the rest will disbelieve."[11]

In response to the recent speech controversies that have engulfed college campuses, Anthony Kronman put it this way: "To assign a normative weight to private sensations and beliefs in a way that insulates them from public scrutiny destroys the possibility of Socratic inquiry. . . . This makes the public sphere of reason hostage to the private realm of feeling."[12] To be sure, personal experiences are an essential element of the creative act, and therefore must remain a central concern in the realm of artistic imagination, but such individualized experiences are in themselves not helpful for public discourse seeking evidence-based truth, whether it concerns a scientific question or an art-historical one. We need to distinguish here between respect for

the legitimate, and utterly unique, realm of personal experience in the province of human creativity from the evidence-based materials of scholarship, which must be open to shared evaluation, scrutiny, and debate. The fulfillment of the museum's mission depends upon respect for the former as an essential part of personal expression and adherence to the latter as foundational in the search for truth.

The third rule of engagement is to acknowledge the importance of public opinion for its capacity to counter the threat of overreaching governments and other societal pressures, while also recognizing that it can be "perverted from an instrument of liberation into an agent of repression."[13] This concern was first expressed in the nineteenth century by Alexis de Tocqueville, who was himself a great admirer of the American democratic experiment. A French aristocrat who understood well the shortcomings of European feudal and hierarchical systems of governance, Tocqueville was an early champion of American democracy, but he cautioned against the "tyranny of the majority," which he saw as a predilection toward uniformity of opinion over the independence of individual voices.[14] For Tocqueville, the American experiment needed to contend with the paradox of sustaining both egalitarianism, which embraces all humanity, and excellence, which respects individualism, open inquiry, and the capacity for dissent. As Ronald Collins and David Skover have argued, "The liberty of self is meaningless if one must always conform to majority will."[15]

In the current environment, the potential consequences of challenging majority-held views has greatly suppressed open de-

bate, leaving many who hold opposing views to remain quiet simply out of fear of retribution. One recent example of such consequences occurred at The Met. In the weeks following the murder of George Floyd, and in response to the growing movement to remove, deface, or even destroy public monuments celebrating objectionable people—racists, fascists, anti-Semites, and others—Met curator Keith Christiansen posted on Instagram a plea for the preservation of cultural property, even at a time of impassioned activism and genuine social progress.

Christiansen, then the John Pope-Hennessy Chairman of European Paintings at The Met, was fulfilling a core curatorial responsibility to protect cultural property under all circumstances. Although few could argue with such a position in theory, Christiansen made the unfortunate decision—even if he did so inadvertently—to post his plea on Juneteenth and to use language that could be misconstrued as hostile to the Black Lives Matter movement. His plea was accompanied by a drawing of nineteenth-century French archaeologist Alexandre Lenoir, who fought to save the art of Paris that had become imperiled by the ravages of the French Revolution. The controversy revolved around Christiansen's choice of words, referencing the French "revolutionary zealots bent on destroying the royal tombs of Saint-Denis." Within hours, the post had drawn widespread condemnation, alleging that Christiansen was making "a dog whistle of an equation of Black Lives Matter activists with 'revolutionary zealots.'" These criticisms were accompanied by numerous demands from far and wide that museum leaders take action—in some unspecified form—to discipline Christiansen

as a way of countering "a deeply rooted logic of white supremacy and culture of systemic racism" that was seen to exist at The Met.[16]

For his part, Christiansen was deeply remorseful about the controversy his post had engendered. He soon issued an apology in a letter to Met staff, which was also made public, stating in part, "I had in mind one thing and lacked the awareness to self-reflect on how my post could go in a very different direction on a very important day." He went on to say, "I want to be clear on my view that monuments of those who promoted racist ideologies and systems should not be glorified or in a location where they can cause further harm."[17]

Like the Garrels incident, the Christiansen situation revealed much about how vigilant the museum community and wider public had become to perceived acts of racism or disrespect, but it also showed how vulnerable each of us was becoming to public criticism or censure. To be sure, Christiansen's post was insensitive with regard to language and timing, but the avalanche of public condemnation was not proportional to the actual content of the message. If we could see past the objectionable language of the post, we might be able to acknowledge that Christiansen was making a plea for history, that we take the long view and preserve the art—or more neutrally, the evidence—of our time. Preservation of cultural materials is the most important role museums play in our society, now and always. The idea that Christiansen was putting forth was both important and timely, and he saw it as his responsibility to speak out. Near the end of a long and illustrious career at The Met, Christiansen was confronted by an

avalanche of criticism because a single good idea had been, in a moment of urgency, unartfully expressed. With the accelerant of social media, Tocqueville's caution about the perils of public opinion has become an existential threat to substantive debate, at least when it comes to difficult issues.[18]

Museums, like other public spaces with scholarly and educational ambition, have a responsibility—to their own missions and to those whom they serve—to create spaces dedicated to protecting the free exchange of ideas; this requires special support for minority voices against the leveling pressure of public opinion. Because the mission of museums is to expand boundaries by generating new knowledge and ideas, they have a special obligation to foster open and rigorous inquiry, even if there is a risk of causing harm or insult. In my own experience, it is at the nexus of personal discomfort—when we are closest to confronting our own biases or ignorance—that real learning can occur, if we are open to it. For museums to do otherwise will inevitably restrict the free exchange of ideas even further within the natural boundaries arising through professional, evidence-driven inquiry. Our efforts within the museum are most productively deployed not in regulating what constitutes acceptable speech but in helping all participants to understand and appreciate what is at stake if we fail to support fully and openly a free system of intellectual and cultural exchange.

For the public sphere to function as it should, all of these conditions must be met, at least at some level. If they are not, the inevitable result is a distortion of the debate and the subjugation of honest inquiry. Fundamentalism of any kind—by which I mean

those who hold an authoritative grip on the truth and will decide for others what is right—along with other forms of thought intimidation undermine the museum or any other public space as a productive forum for the exchange of ideas. As Habermas implied in outlining these conditions, the public sphere—be it a town square, a coffeehouse, or an art museum—requires careful tending to or it loses balance, inevitably to those who possess the most power and who hold a directed agenda, the result being that the prejudices of one group masquerade as received truth for everyone else.[19] These forces, put forward by imperfect people with their own biases—well-intentioned or not—are in contention at every turn, requiring active stewardship and transparency to hold them in balance. It is the role of the museum as a responsible public space to protect these values at all costs against those who would undermine them, regardless of their reasons. This we have not done especially well in recent years. The way forward will require museums, no less than colleges and universities, educators and scholars, to enforce community standards about the intellectual value of honest and open inquiry, to reaffirm institutional missions seeking truth and greater understanding, and to set appropriate guidelines for discourse and engagement. We all benefit if we do these things and secure a platform for all voices to contribute.

Having recently witnessed the NASA *Perseverance* rover land on Mars after its two-hundred-million-mile journey from Earth, I reflected with new clarity on what becomes possible in a genuinely open marketplace of ideas. It occurred to me that what

we had witnessed was actually the cumulative result of thousands of individual ideas, each of which had been proposed for review among knowledgeable peers before being subjected to merciless analysis and rigorous debate, with the result that only the most resilient would be accepted. No one can doubt that the end result—a synthesis of the very best of these ideas—was able to achieve an objective infinitely beyond the capabilities of a system that does not subject its ideas to rigorous review and criticism. Although it may appear to be a very different thing, much the same can be said about a universalist art museum, which contains the finest creative ideas of countless civilizations across the entire arc of human history. With such a remarkable cultural resource, and a mission to pursue greater understanding through scholarship and discovery, we have a fundamental obligation to examine deeply the history and meaning of human creativity, even while acknowledging that our investigations are imperfect, sometimes hurtful, and never-ending. As James Cuno, the former president and CEO of the J. Paul Getty Trust, has eloquently argued: "The encyclopedic museum . . . was founded on the Enlightenment principles of suspicion of unverifiable truths, opposition to prejudice and superstition, confidence in individual agency, the public exercise of reason, and the promise that critical inquiry leads to truths about the world for the benefit of human progress and the forging of a common, pluralistic identity from our highest, most noble aspirations."[20]

Difficult Ideas and Who Gets to Have Them

When museum professionals are doing their jobs effectively, they will inevitably face criticism and the prospect of controversy and occasionally make errors. This is as it should be, since it means that the mission of the museum is being realized and audiences are substantively engaged. Controversy can emerge in any number of places, from questions concerning works in the permanent collection, as happened recently at The Met, to other areas, including special exhibitions or programs, live arts performances, publications, or simply in the course of public debate on controversial topics.

The Whitney Biennial has been a source of dynamic programming, lively public discourse, and occasional controversy on the subject of American art since the program was first put in motion in 1932 by the museum's founder, Gertrude Vanderbilt Whitney. Now a biannual event, the exhibition seeks to explore new visual ideas with the presentation of recent work by invited artists, with each object chosen for inclusion in the show by the museum's curators. The program for the 2017 biennial was especially ambitious, seeking to explore the complex and challenging issue of race in the United States. As curators Mia Locks and Christopher Y. Lew described on the museum website: "At a time rife with racial tensions, economic inequities, and polarizing politics . . . artists challenge us to consider how these realities affect our senses of self and community." [21]

One of the works selected for the show was by the artist Dana Schutz, an oil painting called *Open Casket,* which depicted in

highly abstracted form the tragic image of fourteen-year-old Emmett Till at his funeral, after he had been murdered and disfigured in the summer of 1955. The curators first saw the painting in Schutz's Brooklyn studio before it was sent to Berlin for a gallery show in 2016, where it generated no controversy. The subject of the painting is highly sensitive and generally difficult on many levels, but the use of disturbing, violent imagery was in keeping with a theme found in many of Schutz's works. The immediate source for *Open Casket* was a photograph of the murdered Black youth in his casket, a wrenching image that his mother, Mamie, wanted all to see so they could understand what had happened to her son. The photo caused a sensation in 1955, at the time it was published, and soon was widely available, becoming an iconic image that helped to inspire the civil rights movement. For Schutz, who is white, the subject of Emmett Till was not one that she sought out; rather, as she tells it, she felt compelled to create the painting as an empathetic response to the excruciating pain endured by Till's mother, which was evident in a series of photographs from the funeral.[22] In selecting *Open Casket,* the curators knew that the image would generate questions and debate, but it was not the only image of violence they selected among the works of sixty-three artists in the exhibition. After all, they were taking on the topic of "racial tensions, economic inequities, and polarizing politics." In deciding to address these challenging themes, the Whitney was explicitly creating a forum to explore difficult ideas.[23]

However, even for Locks and Lew, the controversy that erupted over the Schutz painting was greater than they had an-

ticipated. Among the first to speak out against the painting, British artist Hannah Black posted on Facebook a blistering critique with the demand that *Open Casket* be destroyed, writing, "It is not acceptable for a white person to transmute Black suffering into profit and fun."[24] Black's letter was cosigned by forty-seven artists and critics, all Black representatives of the art world. The post was soon followed with a protest by the artist Parker Bright, who stood for several hours before the image, partially blocking the view of others, while wearing a T-shirt inscribed with the words "Black Death Spectacle." In the days to follow, the Whitney community, as well as the art and social media worlds, erupted in a heated debate on the propriety of a white woman painting an image of Black suffering. The views being expressed covered every conceivable position, from calls, such as Hannah Black's, for the destruction of the painting to a full-throated defense against censorship of any kind. *New York Times* art critic Roberta Smith had it right in observing, "Once released into the public sphere, images proceed under their own power and, in a free society, they will be used by anyone drawn to them, in ways that will be judged effective, inconsequential, or egregious."[25] Stepping back from this particular controversy, the performance artist Coco Fusco made clear that creative expression can be difficult, saying, "If I want an art world that can handle more than pretty pictures and simplistic evocations of identity, I understand that I will have to support not only difficult subjects but clumsiness and mistakes."[26] For her part in the matter, Schutz said, "I don't know what it is like to be black in America but I do know what is like to be a mother. Emmett Till

was Mamie Till's only son. The thought of anything happening to your child is beyond comprehension. Their pain is your pain. My engagement with this image was through empathy with his mother."[27]

Of course, the central question behind the Whitney controversy was about *who* gets to have difficult ideas on questions of race. For Black and Bright, the right to use the image of Emmett Till should be determined by those who would be more capable of understanding its pain and poignancy. In her letter, Black went further in arguing not only that the subject of Emmett Till should be off-limits to "non-Black" people, but also that the photograph itself was beyond their understanding.[28] In making his own protest as a performance within the museum, Bright prevented others from seeing the picture on their own terms and in so doing insinuated himself into the story.

For those who would restrict Dana Schutz or any other non-Black person from depicting the subject of Black suffering, we must confront the difficult question of whether the actions of Black, Bright, and their followers were themselves acts of behavioral racism, a term used by Ibram X. Kendi to describe the practice of reducing the actions of individuals to their membership in a group. In the case of *Open Casket,* Hannah Black and her associates argued that Schutz was unqualified to represent images of Black suffering by virtue *only* of her race. Kendi has argued, "Every time someone racializes behavior—describes something as 'Black behavior'—they are expressing a racist idea. To be an antiracist is to recognize there is no such thing as racial behavior." Kendi's work is dedicated to the idea that racism is not a

pejorative term but rather a descriptive one, referencing the practice of making judgments about what individuals can know or experience only on the basis of their race, thereby reducing individuals to simple representatives of a particular racial category. By contrast, according to Kendi, antiracism is to view individuals as a thing apart from their race, each with their own experiences, passions, and potential.[29] No one—presumably including Parker Bright and Hannah Black, neither of whom had ever spoken with Schutz—can actually know the inner experience that inspired Schutz to create her image of Emmett Till. In the end, the work of art must engage its viewers on its own terms. It is the museum's responsibility to allow that to happen.

It is, I think, a simple but logical matter to extend this kind of categorical thinking into the realm of the absurd. Should Francisco Goya, the highly successful court painter of the Spanish aristocracy, have been prevented from creating his profoundly haunting images of the suffering poor and dispossessed? Should Maya Lin, a young Chinese American college student, have been chosen to create the national memorial to U.S. involvement in Vietnam? The protests against Lin—for her age, gender, and race—were unremitting, even though she had been selected in a blind competition. Should Gerhard Richter, a German non-Jew, have been denied the right to create the *Birkenau Paintings*? As Peter Schjeldahl wrote in the *New Yorker* in reference to the Richter paintings, "Who dares to take history's ultimate obscenity as a theme, or even an allusion, for art?"[30] As a thought experiment, we can all imagine how much we would have lost if the rules of engagement were being set with such restrictions in

mind. As Jonathan Rauch has written, "The only-minorities-can-understand argument is anti-intellectualism at its most rancid."[31]

However, this leaves open the question about the place of dissent or criticism within the museum. To serve as an effective forum for ideas, there must be room for debate and disagreement, even it becomes heated or hurtful. To be sure, Black and Bright had every right to express their opposition to *Open Casket,* and to do so in any way that felt authentic for them—with the provision that their actions not impinge on the rights of others. By impeding others to have free access to the painting, Bright had intruded on their rights, and in so doing, he violated Habermas's principle that there be no hierarchy of discussants in a free and open forum. As a museum leader, I have worked hard to protect the rights of those who wish to criticize or protest, even when it occurs within my museum, but I insist that those rights do not extend to the abridgement of the rights of others. In commenting on the Schutz controversy and the options for critique, Zadie Smith summed it up nicely, saying: "The solution remains as it has always been: Get out (of the gallery) or go deeper in (to the argument). Write a screed against it. Critique the hell out of it. Tear it to shreds in your review or paint another painting in response. But remove it? Destroy it?"[32] In writing about the Till case and the Schutz controversy, philosopher Susan Neiman argued for the value of a diversity of views, writing: "Looking at an event from multiple angles is the only way we can approach something like truth. . . . I am enriched, not diminished, by the reflections of others. Some things you see best from a distance."[33]

To judge from the number of visitors, the media attention directed toward the show, and the debate that the Schutz painting generated, the Whitney Biennial was a resounding success. Although difficult issues were explored in ways that caused pain for many—including Schutz—the museum served as an effective and highly productive forum for debate and shared learning. This is exactly what museums are supposed to do.

Shortly after the Schutz controversy at the Whitney, The Met was faced with its own moment of criticism, in this case for a painting in the permanent collection that had been on view in its Modern Galleries for more than twenty years. The objection was raised by Mia Merrill and her sister Anna Zuccaro, who visited the museum in November 2017. In passing through the Modern Galleries, they encountered a painting entitled *Thérèse Dreaming,* by Balthasar Klossowski, the artist known as Balthus. Executed in 1938, when Balthus was thirty years old, the painting is of the adolescent Thérèse Blanchard, the daughter of a restaurant worker who lived near the artist's Paris studio and served as a frequent subject of his paintings. The Met image is one of the finest examples of Balthus's distinctive, if unsettling, style of observational realism, which often included sexually suggestive depictions of adolescent girls. Within the darkened, austere interior of the artist's studio, the young girl leans back languidly with her eyes closed and her hands clasped above her head, apparently lost in her own reverie, with one leg raised, exposing her white cotton underwear beneath her red skirt.

An artist who defied the obvious modernist categories of the time, Balthus was nonetheless highly influential and widely

admired, even as his subject matter could be disturbing. In his paintings of young girls in sexually suggestive positions, such as this one, Balthus leaves the viewer to ponder the meaning of this intimate scene. Is the young girl lost in her own innocent daydream, seemingly unaware of her suggestive pose? Or is she being perversely exploited? For some viewers, the image provokes a sense of revulsion, as was the case for Merrill and Zuccaro. For others, such as the critic Lauren Elkin, the painting provides a liberating view of the rarely mentioned topic of a young woman's blossoming sexuality.[34] Always controversial, Balthus's work has reasonably and appropriately engendered even more scrutiny and criticism as we have become more attuned to issues about the objectification of and violence against women.

When Merrill and Zuccaro first encountered the painting, they were taken aback by what they understood to be a depiction of a sexually exploited young girl, the meaning of which they simply could not understand. In communicating their objection to the museum, they requested, in the form of a petition eventually signed by more than eleven thousand people, that The Met "be more conscientious in how they contextualize those pieces to the masses. This can be accomplished by either removing the piece from that particular gallery, or by providing more context in the painting's description." Merrill went on to propose language for such a context: "For example, a line as brief as 'Some viewers find this piece offensive or disturbing.'"[35]

In the course of a series of exchanges with Merrill, we learned more about the nature of her concern, but we did not agree to remove the painting, nor did we agree to place a sign outside the

gallery warning visitors about what was inside. In our view, to include a trigger warning, as Merrill proposed, would presume to anticipate the viewer's reaction, which we were unwilling to do in this case. However, we did acknowledge that we have an obligation to make clear on our labels and other didactic materials why this controversial image is important enough to be in our collection and on our walls. In this respect, we had fallen short of our responsibility to educate and inform. In modifying our label, our objective was not to guide any kind of response but only to provide sufficient background for those who were interested in learning more or in making a more informed but independent judgment about the work. From this encounter we were reminded that many of our visitors look closely, that they want to learn and understand, and that they expect us to be accountable for what we present. This too is how the museum functions as a forum for ideas. To engage in spirited discussion, all parties need to have the opportunity to understand the reasoning and the basis for the ideas under review.

To be sure, Balthus is a difficult artist, and he is surely not going to make people who encounter his work comfortable, but that is not the primary objective of an art museum any more than it is for art itself. As contemporary artist Sarah Sze has said about her own work: "I want people to think, to question, to engage in their own opinion. That's what a good artwork does—it doesn't please."[36]

6 an enterprise for community

Beyond functioning as a destination of consequence and as a forum for ideas, the American art museum serves an essential role within the wider community as a civic enterprise. Accomplished through a multitude of programmatic offerings—special exhibitions, lectures, conferences, school programs, eldercare and special needs initiatives, live arts performances, publications, and private events, among others—the museum is at its best a vital community resource in service to the public and held in its trust. In contrast to the European model of museums, which were for the most part founded and funded by governmental entities, art museums in the United States were created by local communities who carry the primary burden and responsibility of support, financial and otherwise; this is supplemented in varying degrees, dependent on location and circumstance, by tourism, revenue-generating ac-

tivities, and governmental subventions. In this important sense, the American art museum is an independent entity, not really owned by anyone and functioning as a shared resource and collective obligation.

In addition to their programmatic and mission-related service to communities, museums contribute meaningfully to the local economy in driving tourism, increasing consumer spending, and creating jobs. For example, in 2019 (the last full year prior to the Covid pandemic), The Met contributed $5.4 billion to the New York economy through its direct spending, including staff compensation and its own purchasing, and indirectly through the impact of museum-based tourism on local businesses. Of course, the presence of cultural institutions provides widespread opportunities for intellectual and creative engagement, personal enjoyment, and social interaction, all of which stimulate further investment in the community over the long term, including in local businesses, schools, real estate, and the like. By contrast, it is not difficult to imagine that New York, or any major city, without a vibrant cultural life—museums, theaters, or libraries—would be less appealing to visitors, and less interesting as a place to live. Even among the most radical critics of museums today, it is acknowledged that the presence of art and other forms of culture adds to the quality of life and serves as powerful driver of the local economy.

As civic enterprises of cultural and economic importance, museums have become increasingly relevant as venues for spirited debate about governance, funding, participation, and, perhaps especially, accountability. If the museum

is understood to be genuinely a community resource, there is inevitably—and appropriately—a healthy basis for active negotiation about what it does, from collection development and programming to governance and board representation. It is this community-based character that fundamentally distinguishes the American art museum, and it is the expectations deriving from this essential mission that ultimately define its purpose and practice. A grassroots community orientation was the guiding vision for most of the early museums in the United States, including both The Met in New York and the Museum of Fine Arts in Boston, and it has remained a core objective ever since. The same can be said for most American art museums of any size, from the Kimbell in Fort Worth, Texas, to the Wadsworth Atheneum in Hartford, Connecticut. For such an embracing mission to be successful—and it has become increasingly clear in recent years that most cultural institutions have fallen short in fully realizing this community-wide ambition—the museum has to be accountable to a wider range of its constituents than has been the case historically. This too is the key point of distinction for the American art museum. For the most part, it is a civic enterprise held in trust for the public, with the expectation of widespread representation across its range of activities and within its systems of governance. The American art museum is often a site of public contention and disruptive activism due to the tension that inevitably results from navigating such ambitions within a rapidly changing and polarized society. In my view, public engagement, lively debate, and occasional protest are signs of institutional health and fidelity to mission. Active

engagement in various forms is evidence that the work of the museum is reaching people, albeit in ways that are not always satisfying to everyone—which sometimes means that critics respond with conviction. Fear of such forms of engagement is to miss the point about the core mission, which might then devolve into programmatic mediocrity and mission debasement.

For the museum fully to reach the audiences it was founded to serve requires that leadership—by that I mean administrators, boards, curators, educators, and program developers—accomplish simultaneously several related objectives. These include the development of programming that genuinely engages diverse audiences, achieving a better understanding of how to remove barriers to access for historically marginalized groups, and the deployment of widespread messaging that clearly communicates the museum's aspirations; all this requires careful thought and deep engagement with the disparate communities where audiences live. To reach people who have never visited the museum, and may not have felt welcome in the past, museum leaders need to develop a concerted strategy to engage them authentically, while creating a sense of welcome and excitement. These are not simple goals. For genuine change to happen, museum leaders must also commit sufficient resources for the long term, and they must have professional staff who are alert to the particular challenges and long-term process of change. In the aftermath of the national protest movement that emerged in the spring of 2020, there is reason to believe that progress is now underway.

Who Pays?

At the center of the idea of the museum as civic enterprise is the important question about where responsibility resides for sustaining public-facing organizations that are not primarily funded by the government—which is the case for most American art museums. This requires careful reflection about what it means to be a shared obligation when a resource is intended to serve the public good. To be sure, most would acknowledge that it might be problematic for a cultural institution ostensibly dedicated to diversity to derive all, or even most, of its funding from a single source, whether it be a wealthy individual or the government. Of course, there are outstanding American museums that derive significant funding from the government, as does the Smithsonian Institution, which consists of nineteen distinct museums and galleries. However, even for the Smithsonian, the percentage of funding that actually comes from government sources is only 53 percent, leaving the rest to be raised in other ways.[1] What matters for all of these institutions—from the Museum of Modern Art in New York, which receives almost no government funding, to the National Gallery of Art in Washington, D.C., which derives 80 percent of its funding from the federal government—is the need for independence from any single influence that might dictate priorities for collection development, programming, staff hiring, board recruitment, and so forth. Such individualized influences can become coercive with the slightest provocation, even when

it is unintended—as, for example, in cases where the museum encounters controversy in advancing its programmatic work, or when difficult choices must be made in allocating limited resources. As former Yale president A. Bartlett Giamatti wrote in reference to universities, but which is also true for museums: "In a society that believes in pluralism, of institutions as well as values, it will be a significant loss when the private impulse toward the public interest will only be sustained by the constitution of special-interest forces."[2]

What, then, are the obligations of the wider community— beyond a small group of wealthy donors—to the museum, and how can those obligations best be met? If we are to agree that a museum can best maintain its independence and service to the public by ensuring that its funding comes from diverse sources, we must ask how we can develop a sustainable model of co-investment that allows all stakeholders to contribute at a level that is appropriate and manageable.

In recent years at The Met, we faced our own version of this question when we decided to make major changes in our admissions policy for the first time in almost fifty years.[3] At issue was the museum's long-standing, and generally appreciated, pay-as-you-wish policy, which had been in place for all visitors since 1971. The policy was relatively simple to communicate and to manage: all visitors were required to pay something upon entry, but the actual amount they contributed was entirely discretionary. The museum posted notices at ticket windows, on the website, and elsewhere recommending an entrance fee by category—for adults, students, seniors, and children—but by

agreement with the city stipulated that the actual amount paid was up to the visitor. Some groups, including international tourists, were more inclined to pay the recommended amount, while others, such as New Yorkers and other frequent visitors, often paid less. Some contributed only a few pennies. Staff were under strict instructions to allow visitors to decide freely what they wished to pay without any sales pressure.

The program was laudable for its aspiration to achieve perfect equity among visitors and as a progressive social experiment, and it worked reasonably well for many years. But more recently the policy had begun to fail, as we discovered when we began our review: in the decade immediately prior to 2018, the year we changed the policy, the percentage of adult visitors paying full price had decreased from 63 percent to 18 percent, which resulted in a significant decline in revenue. The museum had been facing ever-increasing costs, most of which were beyond its control—staff salaries, healthcare benefits, technology and other equipment, security, facilities care, and more—while enduring a freefall in admissions revenue, our most important source of earned income. The inevitable consequence was a rising and unsustainable deficit, resolvable either by a commensurate reduction in operating expenses, which would inevitably have a destructive impact on mission-critical programming, or the restoration of funding.[4] In the years leading up to this difficult decision we had already been working hard and effectively on strengthening other sources of revenue within the museum, including restaurant services, retail sales, membership programs, and, of course, fundraising.

As a lifelong devotee to The Met, I was grateful for the flexible admissions policy, especially when, as a student, my own resources were quite modest and I wished to make frequent short visits, which was generally my practice. Like so many others, I was comfortable paying only a few dollars for my visit, but I must admit that the policy also confused me, since I did not know if the museum actually needed the money. Like many others, I speculated that it did not. The truth is that we needed the money, then and now. The inexorable costs associated with running a major art museum tend to rise with significant labor, facilities, and fixed costs in a manner that is commensurate with the general growth of the economy, as markets dictate increases in salaries and upgrades in technology as well as the cost of scholarly materials and various professional services.

Beyond the issue of financial need, we must return to the question of what constitutes an equitable model for co-investment in a community-based enterprise. If the museum is considered both a shared resource and a collective obligation, it must depend on funding from a wider range of donors than only those who are capable of making very large gifts. In addition to the financial benefit of a larger pool of potential supporters, even if some of them are relatively modest in what they can give, there is genuine value for all in a model of co-investment for an institution that is collectively owned and utilized. Frankly, I have never understood the reasoning of some critics who maintain that the wealthiest among us have the obligation of underwriting the full cost of running the museum for the benefit of everyone else, meaning that the rest of us are obligated to contribute nothing. This is not

only unethical from a community-engagement point of view, but it is also a bad management idea, since it makes our institutions less independent. Such a skewed funding model also projects a distorted view of what collective ownership actually means. If we don't want the wealthiest donors to assume an excessive sense of proprietorship over the museum, we should make every effort to distribute both the burden of support and the benefits of investment to all who have an interest in its mission and work.

As a result of this thinking, and in response to the discouraging news that our pay-as-you-wish policy was no longer working, we decided in 2018 to modify the policy. As a member of the city's Cultural Institutions Group, any admissions policy change required city approval, and we worked to develop a policy that would serve this important partnership. Our approach remained equity-based and with an eye toward what we believed was a fair and sustainable model of co-investment that would have the least impact on New Yorkers. For all New Yorkers, the pay-as-you-wish policy did not change because residents of New York were already contributing to the well-being of the museum through their city and state taxes, which translated into annual government support of about 9 percent to our operating budget.[5] All others were asked to pay an established entrance fee based on their particular status: seniors, students, adults, children, and so forth.[6] For those who planned to visit often, we also offered modestly priced membership programs that ensured free admission along with other offerings. To be sure, our decision to change the policy was controversial, and it received a great deal of attention in the media when it was announced. We worked

hard to communicate the basis for our decision, with transparency about the underlying finances and visitor practices, and we spent a great deal of time answering questions for the media and others.

I certainly had not contemplated changing this policy when I came to The Met, but in the course of study and reflection, I believed that it was the right thing to do. I had thought carefully about the obvious alternative: to use our considerable endowment to increase access by lowering fees or even making the museum free to all, as some had suggested. However, the endowment had been created expressly for the purpose of building a superb scholarly and educational institution, and, of course, a world-class collection, all of which requires substantial ongoing investment. To redirect significant resources away from those areas in order to obviate the need for admissions revenue would inevitably transform the mission of The Met from an extraordinary scholarly institution and program generator to one that would be less able to invest in innovation, extensive educational programming, deep learning, global impact, or new ideas than it had in the past. In my view, this would mean that, over time, the museum would fall increasingly short of its foundational mission, facing inevitable decline. Our position was to restore the needed funding by asking all who had an interest in the museum's flourishing to share modestly in its cost by paying a reasonable fee for entry.

A related, and equally important, aspect of co-investment concerns fundraising, which is at the heart of most American cultural organizations. Given that a museum is a community-

held enterprise, museum leaders are asked with increasing frequency who gets to participate in its work and whether we should draw limits on who is permitted to contribute to its funding. As we have seen in recent years, this issue is increasingly visible in the news. As a thought experiment, most of us can easily imagine that certain donors would be unacceptable to participate in funding a community-oriented museum. This might be someone with a criminal background or an egregious record of involvement in activities that run counter to the values of the museum, or more to the point, who used money that had been generated from such activities. For most American museums it would be a fairly simple matter to reject a proposed gift from a neo-Nazi organization that offered to create a named gallery, although some museums might still welcome an anonymous gift from such a group. It is more difficult to determine precisely where to draw the line in rejecting offers of support, as in, for example, naming gifts from a fossil fuel company or a tobacco producer. In my experience, it is usually the case that there is no easy way to set boundaries in advance for all possible circumstances, and it would not be appropriate to do so. On the other hand, museum leaders and trustees need to be mindful that clear and transparent principles and guidelines should be set. Each institution has a line somewhere, and it must depend on the thoughtful exercise of principled judgment to decide for itself. My own view is that our primary obligation is to deliver the mission of the museum to the widest possible audience, not to be unduly restrictive about who should be eligible to participate in delivering the mission. Money that is put to good use, even from sources that might

be objectionable to some, does not undermine the core values or programmatic mission of most museums. Of course, this is especially true for gifts from anonymous donors since, in such a case, the museum's good name is not being exploited to launder a reputation. Yet, even for named gifts, I would caution against excessive vetting of donors. Support for the mission is what matters most, and gifts from controversial sources can be put to good use for the benefit of all. To take a hard line on who would be socially or politically acceptable as a donor begs the question about how a community-based institution should be funded.

Like many other cultural and educational institutions, The Met faced questions concerning its relationship with the Sackler family, which included individuals who, until recently, were the owners of Purdue Pharma, the drug manufacturer linked to the opioid epidemic. The Sackler case is complicated for many reasons, not least because The Met began accepting gifts from members of the Sackler family in 1964, long before the advent of the opioid crisis. In April 2019, The Met announced that it would no longer accept gifts of any kind from those family members associated, directly or otherwise, with Purdue Pharma. This action followed similar decisions that had been made by the Guggenheim and the American Museum of Natural History in the United States, as well the Victoria and Albert, Tate, and National Portrait Gallery in the United Kingdom. In July of that year, the Louvre followed these actions by removing the Sackler name from its Ancient Near Eastern Galleries. In December 2021, The Met and the Sackler family made a joint announcement that The Met would remove the names of family members from seven

galleries, and that this action was being taken "in order to allow The Met to further its core mission." In my own remarks, I expressed my thanks to the Sacklers for the gesture, which "aids the Museum in continuing to serve this and future generations."

The ultimate decision regarding what The Met and other cultural organizations do about problematic associations with donors will inevitably rest with their boards, and each case should be adjudicated through the careful exercise of shared governance with administrative leadership and others.[7]

Who Leads?

One of the distinguishing characteristics of mission-driven institutions, whether they are museums, universities, orchestras, or hospitals, is that they are governed by an elected board of trustees that operates within a system of shared governance. If the museum is actually a community resource, held in some form of trust for the public, it is the trustees who carry the fiduciary and oversight obligation.[8] This means that boards are responsible for ensuring the well-being of the museum and fidelity to its mission, which through their actions should reflect the public interest. More specifically, this requires that trustees provide appropriate oversight of the CEO, ensure that resources are being used responsibly and sustainably, and support a strategic direction that advances the institutional mission. How these particular roles are enacted varies by degree across institutions, and from one board to the next, but the central premise is that mission-driven institutions are most effectively led through a system of shared

governance involving trustees, administrators, and others as the need arises. Ultimately, the use of shared governance as a leadership model is dependent most on the CEO, since it is the leader who sets the overall agenda, controls the greatest amount of information, and must decide how much power to share. The best models are based on clarity of administrative and board roles, healthy negotiation, and responsible execution of shared power.[9]

In my experience, the exercise of shared governance, in terms of the kinds of deliberation and the participants, varies with the particular issues at hand. The governance model is dynamic, depending on the moment, people, and issues. This is why it is so important to cultivate thoughtful partners across the institution in good times so that they can help during the bad. Trust is the essential element to effective shared governance.

It is the role of administrative and board leaders to determine how best to resolve particular issues, make decisions, or develop plans. In most cases, the participants would include the senior management, members of the board, representatives of the professional and other staff, and perhaps local officials or other external groups. Decisions that need to be widely supported must benefit from the input of those with a stake in the outcome and the resources to help make it happen. It seems to me self-evident that everyone benefits when a strong consultative model is implemented, since decisions are more fully informed and ownership of outcomes more widely achieved. This does not mean that consensus is required for all decisions, even if that were theoretically desirable; but it does mean that the objective should be to have a sufficient level of consultation to inform key decisions while

achieving a shared understanding of the facts and underlying rationale.[10]

As museums work to achieve increased levels of access to their institutions and more programmatic diversity, they must also reflect carefully on who is serving in leadership roles, both in administration and as trustees. If one criterion of serving on boards is financial capacity, it should not be the only consideration. Perhaps more than any other means, the composition of boards and the specific leaders in place will determine the degree to which mission-driven institutions can fully realize their objectives. Ultimately, this work must be owned and executed by board leadership, for it is they who determine who serves with them and in key management roles.

To function most effectively, the board should be representative of the full community it is intended to serve, which must encompass increasing levels of racial, ethnic, economic, and experiential diversity, as well as a wide-ranging capacity to contribute substantively to the multifaceted work of the museum. This long-standing objective, and persistent source of concern, was acknowledged more than forty years ago by Karl Meyer in his study on art museums when he reported: "No complaint is more often heard—boards should be, to a far greater degree than they are now, representative of their constituencies."[11]

To perform the full range of their duties, boards must have members who are knowledgeable participants in strategic discussions, and they must collectively have expertise in the functioning and oversight of complex organizations, including business and financial expertise, legal matters, human resources, exter-

nal communications, capital project construction and facilities management, and various aspects of community engagement. Finally, trustees are expected to have a demonstrated respect for the museum mission, and to whatever extent they are capable, to provide philanthropic support for its work. In recent years, museum boards have become increasingly dedicated to capacity building in all these ways, which improves internal performance and governance, as well as representational alignment with external communities. Although it is true that philanthropic capacity remains an important criterion for most boards, that responsibility, like all others, need not be distributed uniformly among all trustees. Rather, all members of the board have an obligation to contribute in the ways that they can to the shared work of the museum, which is why the selection of people for membership must also reflect the diverse needs of the institution.

When shared governance functions as it should, there is no more effective way to make major decisions or lead change. The recent controversy over museum deaccessioning policies provides a useful example of how a shared governance model can support thoughtful decision-making, both in response to the urgent situation that arose during the Covid pandemic and in setting policy for the longer term. At issue was whether there should be a change to the long-standing Association of Art Museum Directors (AAMD) policy, which stipulated that the proceeds from the deaccessioning of art should be used only to support new acquisitions and not to subsidize museum operations or other expenses.[12] In light of the urgent financial crises faced by most museums following the outbreak of the Covid pandemic, the

AAMD voted in 2020 to modify the policy for a two-year period, during which time museums would be permitted to use the proceeds from deaccessioning to underwrite operating expenses related directly to collections support. Once this policy had been approved, a new debate ensued about the wisdom of making such a change permanent, since it would give each institution more latitude to decide for itself what was best. Although many institutional leaders expressed support for a permanent change, the most vocal response came from those who were opposed, fearing that such a flexible policy would inevitably erode collections and become, in the words of Thomas Campbell, director of the Fine Arts Museums of San Francisco, "like crack cocaine to the addict—a rapid hit, that becomes dependency."[13] In reflecting on this debate, it seems to me that Campbell and other critics of the revised policy miss an essential point: respect for the processes of institutional governance, a bedrock requirement for all museum leaders. Deaccessioning decisions, under every circumstance at The Met and most everywhere else—including smaller regional institutions as well as university museums—must be made within a multilayered review process, including curators, conservators, the director's office, and the board, that is subject to considerable internal discussion, public transparency, and leadership accountability. The idea that deaccessioning decisions must be subject to rigid regulation *in order to* reduce the risk of a slippery slope into "dependency" is disrespectful to museum boards and their governance processes. The AAMD policy was modified to allow museums to preserve their institutions in the face of an unprecedented emergency, not to make it easier to con-

duct business as usual. Although it is too soon to determine what would be the most useful national guidance for the longer term, such a consideration must recognize the essential role of shared governance, which is highly consultative and must subject any recommendation to a transparent and multilayered assessment. If the relaxation in deaccessioning rules became just another lever to help museums get over bumpy periods, we would actually need to appoint new boards and administrative leaders rather than impose increasingly rigid rules to circumvent malfeasance or incompetence. In the case of deaccessioning, as for all matters of consequence, leaders must make decisions that withstand scrutiny and are suitable for institutions that are built to last. The AAMD deaccessioning policy would be most useful if it were to outline best practices with regard to collection preservation and to set broad parameters for institutional decision-making that can serve as guidelines for boards and museum leaders. The exercise of shared governance within a carefully designed system of checks and balances would then allow the museum to make prudent decisions that must be subject to external review, and for which leaders would be held accountable.

As we look to the future, and a world that will expect more from museums and other cultural institutions, shared governance will need to become more visible and more effective. There is an interesting opportunity here: as the environment becomes more contentious and greater service obligations are being placed on museums, there is new pressure to make decisions that are more responsive to divergent needs. If shared governance is a core principle of leadership, as issues become more contentious with

higher levels of public scrutiny, the quality of deliberation needs to be higher and the support for decisions more widespread. The work has become harder and more controversial, but the solution is to be more open and transparent, not less. This was not the way of the more streamlined decision hierarchies of the past. In the future, successful leaders will need to fulfill the missions of their museums while evolving with the ever-changing needs of the communities they serve. As is often the case in dealing with complex issues and imperfect information, there is generally not an easily available answer, only the best decision that we can muster through careful review and thoughtful consultation.

Based on my experience, for the museum to function as a vital and credible community resource, it needs to have strong oversight processes and a commitment to five core principles:

1. *Shared governance* is not a cumbersome obligation, but a critical resource for strong, mission-driven decision-making. Although it can be time-consuming and inefficient, substantive engagement with those who have a vested interest in the issue at hand will result in a more responsive decision and more durable outcome.

2. *Transparency and accountability* are essential elements in building trust and in fostering productive dialogue. If we believe in the value of open discussion, we have an obligation to provide others with access to our reasoning and the basis for our decisions.

3. *Diversity of funding* is a source of strength because it fosters independence and institutional resilience. The philan-

thropic model, which is at the heart of most American art museums, distributes this shared responsibility most effectively when it is open to all at various levels of giving. This model is preferable even to reliance on a single endowment because the ongoing work of the museum must be responsive to the audiences it is intended to serve, and it must be alive to emerging needs and different voices. Diverse funding sources provide a mechanism for aligning institutions with audiences.

4. Leadership begins with a deep *understanding of institutional mission.* Museums are built to last, but their missions will inevitably evolve through a process of public engagement and careful reflection. However, this should not happen suddenly or in a reactive way. It is the responsibility of administrative and board leadership to review the mission statement from time to time and to make sure that planning is aligned with the mission as it evolves.

5. A system of *checks and balances* helps to ensure that museum leaders and boards are working to fulfill the institutional mission, stewarding resources appropriately, and meeting the needs of various audiences and the public. Operating policies and bylaws should be reviewed regularly, along with assessment procedures that ensure that best practices are being followed. More often than not, well-meaning organizations lose their way because the board is not conducting proper review of leadership and compliance with core policies. This is another reason why it is essential to have diverse

membership on the board so that issues can be spotted and oversight can be thorough.

Critiques for Change

In the aftermath of the calamitous events of 2020—and precipitated by the public spectacle of George Floyd's murder—museums, like so many other public and private organizations, were called to account with new urgency for their own racist actions and problematic histories. The immediate impetus for these critiques was a galvanizing public crisis, but the roots of it were long-standing and cumulative, based on a growing sense of alienation and disenfranchisement felt by many, both from within museum organizations and among the public whom they were supposed to be serving. Because there was widespread recognition that the museum was *intended* to be a community resource in service to all, those who believed they were being left out or who felt mistreated began to speak out forcefully, and often with justification. Although the critiques have been widespread, most center on a few overarching themes: colonialist practices deployed by many encyclopedic museums over many years to build collections and to rationalize a disregard for the cultural property rights of those less powerful; the overrepresentation of some groups—particularly white males—on museum boards and in leadership positions; a demonstrable lack of equity and respect in the treatment of some museum staff members; and a long history of exclusion of the art and narratives of some cultural groups and communities.

Some critiques have gone beyond challenging specific practices to call for categorical change, or even the abolition of the museum itself, at least in its current form. Groups such as Decolonize This Place (DTP) and Change the Museum (CTM) call for more radical change, in some cases to dismantle institutions in their entirety—collections, leadership, and funding—so they can be reinvented along different lines. Hannah Baker is one such critic who outlined her transformational vision to abolish museums within the pages of *Hyperallergic*. She wrote: "The new museum requires an ethical reorientation from our old ways of thinking, a divestment from a conservationist and capitalist ideology, and a centering of voices previously silenced by the colonial project." Baker went on to explain: "Abolition will look like many things: repatriation of artworks and artifacts that have been stolen, paying community members and cultural workers to create repatriation processes that are less about legality and more about repairing harm, cutting ties with the board of directors, creating community guidance councils, opening up museums for housing and shelter, making entrance to museums free, and allowing people to curate shows that are meaningful to them."[14]

In outlining these ambitious goals, Baker leans in on vision but does not touch on how such transformational change might be accomplished—strategically, operationally, or financially. She does not tell us how such a museum would be funded, programmed, or directed. In a recent essay reflecting on this burgeoning protest movement, *Washington Post* art critic Sebastian Smee observed that some of these critiques, well-intended though they may be, are more concerned with the "moral vanity

of righteous gestures" than they are with the "fight for actual solutions."[15] It may well be that such a radically different conception of the museum is a good idea for the new society we are trying to build, but it is not clear to me that creating such a new entity requires the wholesale abolition of those that already exist. As the museums of today embark on their own missions of change, the more radical version as outlined by Baker might best be realized as a new and distinctive effort, and in so doing, add to the richness and diversity of the American museum project. Of course, doing so will require considerable effort in the practical realm of collection development, financial planning, and institution building.

The fundamental question that arises with these critiques concerns the central purpose of the museum, a topic that generates divergent views. In her recent critique of museums, *Culture Strike: Art and Museums in an Age of Protest,* Laura Raicovich made the case that the museum should function as a center for progressive activism to advance societal goals beyond the purview of its collection and programmatic mission.[16] As a vital center for the local community, the museum, according to Raicovich, is not a neutral place, but one beset with existing biases and self-evident power imbalances. To presume neutrality as a normative value is to ignore the reality that power within the museum is not equally distributed. For Raicovich, statements of neutrality should more accurately be understood as affirmations of the status quo, and therefore a proactive stance opposing progress and greater equity. In the current moment, for Raicovich and others, there is no safe harbor in assuming a position of institutional neutrality.

Although I agree with Raicovich that museums must change if they are to serve their communities more fully and effectively, I hold a different view of the museum's core purpose and place in society, which is less centered on activism, and more focused on its artistic mission to ensure cultural preservation, scholarship, education, and public engagement in the realm of ideas. I share the view of Tristram Hunt, director of the Victoria and Albert Museum in London, who has argued, "Museums have a responsibility here—not as vehicles for political posturing, but as trusted arenas of public space, civic leadership, and intellectual credibility." Hunt also acknowledged that museums are imperfect, writing, "Of course they are not pure, neutral and wholly objective, yet museums embody a rigour, transparency, and curatorial knowledge base that can only help to foster an educated citizenry."[17] The work of leading change depends fundamentally on the institutional vision one is pursuing. For Hunt, as for me, the museum idea as it is being realized today is enduring and sound, even if it must continue to evolve to remain relevant, useful, and faithful to mission.

To be sure, reasonable people can disagree about what constitutes an appropriate rate of change, or even how much change would be desirable, but it is undeniable that American art museums are now undergoing dramatic transformation, perhaps more than ever before. Current debates notwithstanding, such a process should not be polarizing, focused on winners and losers. Rather, the disparate needs of the larger community must be held in balance. Like families, large, diverse communities are

complicated. To engage the voices of its various members and to lead effectively, we need to live with a certain amount of debate and disagreement. To create and engage a diverse community is inevitably to manage, on an ongoing basis, different points of view, opposing objectives, and, on occasion, outright conflict. For our communities to thrive, we must all develop more effective ways to engage with each other—not just when confronted to do so, but all the time—and in so doing to listen, learn, and, ultimately, grow. This is why shared governance is so important, since it offers the best model for finding common ground within the context of difference.

By contrast, radical change is simply not a sustainable path forward, even if it is sometimes necessary to address a particular problem or issue. Museums were created to be perpetual institutions, which means that they must be governed with respect for their place in history and, equally, for their continuing obligation to pursue progress and improvement. The museum idea requires that we work together to seek better versions of ourselves as a community, which requires constructive engagement, diverse perspectives, and, where possible, shared learning. The current demands for progress are being heard, and most museums are undergoing processes of significant change, but this work must also have an enduring impact for it to matter. The greatest challenge to leadership is in finding the best path forward that capitalizes on current opportunities for meaningful change while ensuring that progress is genuinely additive to institutional missions and empowering to the community. The ongoing challenge

will be to serve as a meaningful resource for the entire community while supporting the core values of excellence, universalism, scholarship, and equity. To accomplish this work within a more diverse community of stakeholders is substantially more complex, but when it is done well, it is infinitely more rewarding and of enduring benefit to us all.

7
a source of identity and connection

At the time of its dedication in 1870, the founders of The Met said their vision was to create for their growing city a museum and library dedicated to art—its appreciation and study—for "advancing general knowledge of kindred subjects and . . . furnishing popular instruction."[1] Although the priority was for the new museum to serve primarily an educational role—becoming effectively a "Department of Knowledge"—it is an odd omission that the founders were mostly silent about exactly *what* kinds of art they were hoping to collect and display. With few exceptions, it would seem that they were concerned more with the purpose of the museum that they were dedicated to building than they were with what it would contain. In the words of founding trustee Joseph C. Choate, the museum was to be a civic enterprise dedicated to the public good, for whom "the diffusion of a knowledge of art in its higher forms of

beauty would tend directly to humanize, to educate and refine a practical and laborious people."[2] As Calvin Tomkins has observed, these civic-minded leaders, without exception men (and only men) of accomplishment and expertise in various realms, were for the most part not knowledgeable about art. This gap was certainly acknowledged, but it was discounted as a matter of lesser importance in the grand scheme of what they were hoping to accomplish. As trustee Henry Bellows explained at the time, what was needed was leadership, but "men of affairs and enterprise and executive ability are seldom interested in art or marked with a taste and appreciation of the delicate interest of the beautiful."[3]

Of course, it is also likely that the vision for The Met's collection was never really in question since the museum's founders were inspired by the institutions, and artistic legacy, of Europe. One notable exception to this Eurocentric view was George Fisk Comfort, one of the museum's founders, who said at the time, "A museum of art in a large and wealthy city should illustrate the history of the origin, the rise, the growth, the culminating glory, and the periods of decline and decadence of all the formative arts, both pure and applied, as they have appeared in all lands and in all ages of the world." As Joanne Pillsbury has noted, this expansive idea for the museum was soon forgotten in favor of a greater focus on Europe and, to a lesser extent, Asia, that was to endure as the museum's primary collecting objective for more than half a century.[4] Like the museums of Paris, London, and Rome that they were seeking to emulate, the Americans were drawn to the art of the classical world, its European inheritance,

and the various societies that emerged throughout the Mediterranean basin over the course of three millennia. This was generally understood by The Met's founders, as it was for the founders of most art museums in the United States, to be the cultural foundation upon which their museums would be built.

The "Golden Nugget"

This Eurocentric cultural idea, which Kwame Anthony Appiah has called the "golden nugget," was the essence of what the Christian societies of modern Europe had come to understand to be their legitimate heritage. As Appiah has explained:

> From the late Middle Ages through Hegel until now, people have thought the best in the culture of Greece and Rome as a European inheritance, passed on like a precious golden nugget, dug out of the earth by the Greeks, and transferred, when the Roman Empire conquered them, to Rome, where it got a good polish. Eventually, it was partitioned among the Flemish and Florentine courts and the Venetian Republic in the Renaissance, its fragments passing through cities such as Avignon, Paris, Amsterdam, Weimar, Edinburgh, and London, and finally reunited in the academies of Europe and the United States.[5]

The new American institutions that were being established during this period would also extend the Eurocentric vision to collect works produced closer to home, but this was mostly restricted to the painting, sculpture, and decorative arts of colonial America, leaving aside the art of indigenous communities, African Americans, and numerous other groups that were at the time finding a foothold in a rapidly expanding nation increasingly

open to immigrants from far and wide. We cannot be certain whether the original vision of The Met's founders was to create a collection that *they* would have understood to be encyclopedic, but at the time such an objective would more or less have been satisfied with objects limited to the so-called Western canon.[6] In the era of Enlightenment thinking, the cultural production of the rest of the world was not considered "high" art, but rather was relegated to such marginal categories as anthropological, ethnographic, or primitive—meaning that it might be of historical importance, but not worthy of inclusion in a museum dedicated primarily to the aesthetic experience of art.

Yet, over time and with sufficient resources and opportunity, the art of other Western-affiliated cultures was added to the mix, including ancient Egypt (but at first, not elsewhere in non-Roman Africa), parts of East and South Asia, and the most prominent and elite cultures of the Islamic world. In the years that were to follow, at The Met and other major American museums, the ambition to build more expansive collections evolved in response to advances in art-historical knowledge, the emergence of the museum profession itself, and the opportunities that presented themselves for new acquisitions in a rising economy with a burgeoning commercial art market. Just as the nation itself was expanding its boundaries, diversifying its population, and rising as a player on the global stage, the American museum was becoming more self-conscious about its own ambitions to build encyclopedic collections, representative of the changing local population and the wider world.

Although the "Enlightenment" view of The Met founders was

at the outset rather provincial for a museum with such global ambition, their overarching vision was, like most museums founded in the United States at the time, a progressive one. To be sure, The Met, Boston's Museum of Fine Arts, and others were all built within a European colonialist paradigm in the sense that they sought to collect, possess, and control the cultural property of other societies, and in so doing to derive various benefits—social, economic, and political—for their own institutions. After all, the American institutions were following the model of the Louvre and the British Museum that had inspired them in the first place (at least with regard to the breadth of the collection, if not always their methods of acquisition), which by the late nineteenth century had become highly popular and commercially successful enterprises. But this was a model designed to evolve with regard to what it collected, the narratives it presented, and the communities it served. As Susan Neiman has argued, although most Enlightenment thinkers were themselves products of their time—meaning that they too were prejudiced and provincial in myriad ways—they were also self-aware and self-critical, seeking in their work to build the foundations to destroy their own prejudices.[7]

Expanding Collections and Cultural Heritage

The materials placed on view in all of these museums provided new and exciting access to an increasing range of cultures from ever-larger areas of the surrounding world. This created opportunities for increasingly diverse audiences to discover works of

art and narratives that they could relate to their own cultural identities and sense of selves, however such things might be construed. With time and experience, American museums came to embrace the vision—and associated ambition—that they could be more encyclopedic in what they collected and more inclusive in whom they served.

One of the most enduring consequences of such an expansive vision—and associated collecting ambition—has been the problem of determining rightful ownership of property across multiple generations and diverse national boundaries, an issue complicated by evolving laws; ever-changing international agreements; the impact of wars and various other forms of regime change—often violent and accompanied by looting and wanton destruction of cultural sites; and, more recently, new societal expectations that museums honor commitments to equity and social justice. More succinctly, what constituted acceptable collecting standards during the colonial era of the nineteenth or early twentieth centuries are now thought by some to be unacceptable throughout most areas of the world. This, above all, is what the museum decolonizing movement is all about, as activists seek greater independence from exploitation by others through greater control of cultural property, access to knowledge, and shared power.

Within such a changing environment, for most institutions that were founded in the era of the Enlightenment, or on such a model thereafter, there remain challenges and questions about rightful ownership of objects in the permanent collection, just as there are for the British Museum and the Louvre, among oth-

ers. Such cultural heritage issues are not easy to resolve, even with the best of intentions on all sides, and, more often than not, they cannot simply be settled by legal means alone. Nor can long-standing questions about property rights be resolved simply through the application of a contemporary ethical or social justice lens. Rather, greater fairness in determining property rights and intergenerational justice will require in most instances some combination of legal process, political negotiation, imaginative problem-solving, and public advocacy.

Like most major museums that continue to collect, The Met has on occasion encountered serious and credible challenges to its ownership rights for works in its own collection. Sometimes these issues have arisen because the objects have been looted and then sold under fraudulent circumstances, either to the museum directly or to a private collector who later donated the work. Two recent cases that are particularly noteworthy concerned objects from the ancient world. The first was a magnificent Greek vase, widely known as the Euphronios Krater, that was acquired by The Met in 1972.[8] After its widely publicized arrival in New York, evidence began to emerge that the vase had been looted in December 1971 from an Etruscan site in Cerveteri, Italy, before being offered for sale with a fabricated provenance and forged documentation.[9] Although Thomas Hoving, The Met's director at the time, subsequently acknowledged his suspicion that the vase had been "illegally dug up in Italy," he allowed the museum to proceed with the acquisition and secured the funds to make the purchase for one million dollars, which was then a record amount for ancient Greek pottery.[10] In 2005, new evidence

affirmed that the Euphronios Krater had indeed been looted, which resulted in the decision to restitute the vase to Italy in 2006 as part of a comprehensive cultural-exchange agreement between The Met, under the leadership of then-director Philippe de Montebello, and the Italian government.[11]

More recently, during my term as president, The Met acquired an Egyptian object, the so-called Gold Coffin of Prince Nedjemankh, a high-ranking Egyptian priest of the ram god Heryshef of Herakleopolis, which dated from the first century BCE. Just two years after we acquired this remarkable and rare object in 2017, we were presented with compelling evidence that the gilded coffin had actually been looted in 2011, just a few years before it had been sold to us with a fraudulent provenance and forged documents.[12] Once we had this information, we agreed to deliver the artifact to the Manhattan district attorney for return to its rightful owner, in this case the Egyptian government, and to draw the lessons we could to avoid similar errors in the future. For all of us who were involved in these cases, we gained significant new insight into the increasingly sophisticated criminal practices of those who plunder ancient sites, and we acknowledged our responsibility to exercise greater care in conducting our review of objects for potential acquisition. This remains an ongoing and serious problem throughout the cultural world, which many American institutions, including the Getty and the Smithsonian, as well as The Met, are working hard to address by developing new collecting standards, as well as improved legal and scientific approaches to object verification and authentication.

At The Met, after restituting these objects and others, we have continued to modify our acquisition procedures to ensure that we are conducting the due diligence required to verify the legal title of all artifacts and the accuracy of their provenance. Of course, we must learn what we can from these cases, working with our boards to identify the fraudulent practices we encountered and our own errors that led us to commit to these purchases.[13]

Among the types of violations to established cultural heritage practices, outright theft and fraudulent documentation are at least straightforward in their resolution through recourse to criminal investigation and legal action. The problems of ownership of cultural property can be far more complex, both historically and ethically. Such is the case, for example, in the matter of the so-called Benin Bronzes, a group of more than three thousand objects of varying materials—bronze, brass, ivory, and wood—that were looted during a raid of Benin City (in present-day Nigeria) by the British military in 1897. During this infamous "punitive" action of colonialist violence and looting, which was staged as retribution for the murder of unarmed British explorers, an invaluable cultural and historical treasury of the Benin people was plundered and subsequently removed to Britain. There, some nine hundred objects were added to the collections of the British Museum, and more than two thousand additional works were dispersed to other museums in Britain or auctioned off to museums and private collectors throughout Europe. Eventually, these looted objects were acquired by more than 160 museums around the world, often with complex provenances marked by numerous changes of ownership.[14]

In recent years, the controversy over the rightful ownership of the Benin material has become a highly visible example of the complex ethical challenges associated with colonialism in the cultural sphere. There is neither a question nor a controversy over who owned these works prior to the British raid of 1897, nor over the extraordinary importance they held for the Benin people. Further, there is widespread acknowledgment that the British military action was excessive and that the looting of the Benin material was entirely unjustified, even for its time.[15] What remains less clear in the eyes of many—museum leaders, governments, cultural heritage organizations, and others—is how legal ownership can *now* be established, given the passage of 125 years and the subsequent, complex ownership record of these objects, most of which are distributed among museum collections throughout the world.

Despite such formidable challenges, there is recent evidence of movement on the various questions concerning the ethics of possessing such important cultural and historical material that was forcibly taken from its original owners. As the historical meaning and circumstantial record of the Benin Bronzes has become more widely understood, there is greater recognition of the rights of the Benin people and their descendants to objects of such importance to their own history, religious traditions, and identity. As Nigerian leaders have increased their own advocacy for restitution and have acknowledged their concomitant obligation to provide proper care for these cultural treasures, other nations have responded with various initiatives intended to find workable

solutions that respect the rights of the Nigerian people to their own heritage. Among recent developments, the most notable is the 2018 report by Felwine Sarr and Bénédicte Savoy, commissioned by the French government, "The Restitution of African Cultural Heritage: Toward a New Relational Ethics," which outlines new approaches and has thus far resulted in the French government's return of twenty-six Benin objects. Following these French actions, British cultural authorities proposed collaborative arrangements that would allow for loans of their Benin artifacts to museums in Nigeria, along with various other joint projects. Perhaps most noteworthy are the recent decisions of both the German government and the Smithsonian Institution to return to Nigeria some of the Benin materials in their respective collections. For the Germans, this includes a substantial number of the Benin objects that were in their ethnological museum that are known to have been looted in the 1897 raid. This landmark decision to restitute works, "regardless of how they were acquired," was announced as part of a larger cooperative initiative with the Nigerian government that would include German participation in archaeological excavations of Benin City, joint training programs for museum employees, and German involvement in a construction project to house the returned artifacts.[16] More recently, in March 2022, the Smithsonian announced its intention to restitute the thirty-nine Benin objects currently in the National Museum of African Art as part of a larger agreement that would include long-term loans, shared exhibitions, and educational programs in Nigeria.[17] Numerous other institu-

tions, including The Met, which has already returned two Benin objects, have entered into collaborative agreements with Nigerian cultural authorities.[18]

The "right" answer in any specific case—including the various issues associated with the Benin Bronzes—may seem evident to us from our particular vantage point, but it is not always so obvious within the larger historical context and the particular circumstances of the institutions involved. For museums to lead in this area, as they must, institutional leaders and their boards need to be clear about their own policies and values, and they must be transparent in resolving disputes that inevitably arise. Because each issue is generally accompanied by a unique set of circumstances, each dispute must be resolved in light of particular legal, social, and political questions and with respect to the institution's values and policies. There is no broad-stroke solution that will work in all cases. As perpetual institutions that live in the real world, museums must be aware of changing legal and ethical standards. To face such issues across generations is about remediating perceived institutional failures of the past, as such actions are sometimes characterized to be; it is also an indication of positive change and institutional growth, which healthy institutions must attempt to achieve.

Museums are reflections of the societies that build and sustain them, and they too must evolve, as we all do. In advancing this work, uncertain though it may appear to be and varied with each specific circumstance, museums need to be transparent and accountable to maintain the public trust. Equally, museums have a

mission-critical obligation to embrace a collective responsibility for the preservation of cultural material throughout the world, far beyond the purview of their own collections. Although most museums have not fully realized these legal and ethical aspirations as they relate to their own collections, they have in recent years come to recognize more fully the consequences of falling short of this mission, and most are committed to positive change.

Collections, Culture, and Identity

A fundamental aspect of the American museum that differentiates it for the most part from its European models is dynamic collection growth and the commensurate expansion of audiences. Museums such as The Met recognized early on that the relationship between collection growth and audience expansion was a synergistic one; new collecting areas led to larger and ever more diverse audiences, which gradually shifted the emphasis of most museums from a focus exclusively on objects to also consider the experience of visitors and their various modes of engagement.

As museum collections evolved from a more or less strict adherence to the idea of the Western canon to something more expansive, there was a consequent rise in the number of cultures that the museum would need to understand and study. As the museum profession itself evolved, the need for curatorial expertise in all of its collection areas became more acute. With this

increased level of diversity in its collections and expertise in its curation, there emerged new interest in the idea of cultural identity as a component of the presentation of objects and the experience of visitors. To present narratives of works of art in context required a deeper understanding of the cultural traditions from which they emerged. Because cultural objects provide evidence of our affinities, associations, values, and tastes, they are inevitably associated with our own sense of identity. Increasingly, the museum was recognized to be a place where visitors sought to find some version of themselves, or at least the cultural aspect of what they thought to be most meaningful. Whereas it may not always have been thus, it is certainly true today that for many people, the museum is a place for self-discovery.

For David Bromwich, notions of culture and identity are certainly linked, but they are not identical, even if they are often confused as being the same thing. Bromwich has challenged the idea of "culturism," arguing: "'Culturalism' is the thesis that there is a universal human need to belong to a culture—to belong, that is, to a self-conscious group with a known history, a group that by preserving and transmitting its customs, memories, and common practices confers the primary pigment of individual identity on the persons it comprehends."[19] Bromwich went on to argue that it is a mistake—or rather a trivialization—to equate culture with identity or to see either as immutable. To explore the collections of a large, comprehensive museum is to see the manifold connections between cultures, to celebrate the myriad ways in which we are constantly learning from each other and inspired to create

works of beauty and originality from the example of others. In the Egyptian galleries of The Met, one can discover magnificent examples of pottery, created more than five millennia ago, that resemble the kind of modernist objects one might find in a chic gallery in SoHo. Or elsewhere within the spaces of the museum, one can find myriad examples of our common humanity in the works of Renaissance Italy, sub-Saharan Africa, ancient Assyria, and China's Ming dynasty. If one looks carefully, throughout the museum there is evidence of our universal humanity, expressed in a seemingly infinite variety of forms across a disparate array of cultures and peoples.

In time, and with careful growth and mission expansion, the museum has become a place where these disparate cultures and distinct identities can be freely explored; at the same time—because the evidence is incontrovertible—we must recognize that we are all interconnected, bound to each other in complex and inextricable ways. The joy of the museum experience is in exploring these disparate cultures, ways of living, and modes of representation that can help us to understand ourselves and our relationship to others a bit more completely. At its best, the museum should be a place that celebrates artistic achievement, while also embracing the idea that cultures are both diverse and interconnected, with an almost infinite variety in how we experience beauty, creativity, and excellence. As Appiah has written: "All cultural practices and objects are mobile; they like to spread, and almost all are themselves creations of intermixture."[20] If our understanding and appreciation of cul-

tures is increasingly nuanced, it must also be understood to be neither sealed nor rigidly defined but rather the result of "living a life with others."[21]

While such laudable aspirations and collecting the art of disparate cultures are at the center of the museum idea, a preoccupation with identity on its own terms can lead to forms of tribalism that polarize and reduce a nuanced understanding of the organic nature of human interaction and cultural exchange. Taken to extremes, identity politics are a response to oppression, providing a basis for the assertion of rights and a claim on resources. In serving what are perfectly legitimate political objectives, such a view undercuts the museum's pluralist objectives, inevitably opposing a more communitarian understanding of what the museum is all about.

If the museum is to become primarily a place for activism over contested claims, like so much else in our aggrieved society, then the universalist vision becomes increasingly unattainable. Focusing primarily on race, ethnicity, or nationality as a source of power and identity at the expense of a civic commitment to common ground takes us further away from the universalist idea. To be sure, for many activists the universalist idea is itself controversial in the current moment. For example, in his strenuously argued anti-colonialist polemic on the Benin Bronzes, Dan Hicks categorically rejected the premise of the universalist museum, arguing that "extractive, militarist-corporate colonialism . . . reminds us that the myth of the universal museum [is] in truth a concept antithetical to any ideal of universal human values."[22] Such arguments, built on perfectly legitimate indictments

of historic colonialist practice, nevertheless fail to acknowledge the central premise of universalist museums as they are understood today: as places that draw connections across humanity's disparate cultures, seek pathways to greater social justice, and represent a more effective way of engaging the public in larger questions concerning identity and cultural heritage.

If identity is ultimately about what makes each of us distinctive, we must also acknowledge that the complementary role of community is to bring us together so that we can "live a life with others." The universalist idea acknowledges the importance of difference while focusing equally on what we have in common, including shared values and the ideas that can inspire and unite us all. For an art museum, these ideas include a belief in the importance of beauty, creativity, individualism, justice, empathy, respect, humility, and curiosity. At its best, the universalist museum respects difference, acknowledges that the path to progress is ongoing, and seeks common ground for shared learning and engagement. Such work is not possible if it is focused excessively on a competition for resources, attention, and control between identity groups. As Susan Neiman has argued, the universalist idea is to examine our own distinct histories and identities without "tribalism or trauma," so that we can make profound connections that elevate us all.[23] As the museum evolves to be more inclusive and expansive in its collections and programs, it must be flexible and responsive to the communities it serves, while remaining committed to serious inquiry, discernment in what it does, and the importance of progress. As Joanne Pillsbury has observed, the museum idea requires that we "acknowledge

the fragility of our certainty at any moment."[24] For the museum to fulfill its mission in service to all, its leaders and those who support it must learn to seek balance over struggle, respectful debate over acrimony, and progress over polarization. Like the Enlightenment concept upon which the museum was founded, the universalist idea is progressive, requiring constant growth and change in order to thrive.

Part III

New Directions

8
evolving mission/preserving values

Despite an impressive record of sustained progress —achieved across generations, in good times and bad—the American art museum is today facing new and unprecedented challenges related to core institutional purpose, programmatic mission, and audience. Precipitated by the global Covid crisis, and exacerbated by urgent and long overdue calls for social justice, as well as numerous other civic challenges—including ever-growing disparities in wealth and income, the catastrophic consequences of unchecked environmental degradation, and unconscionable levels of political polarization—the museum is increasingly being asked to do more, to go beyond its art-related mission to help build a better society. For those who support an agenda of dramatic change, the museum is recognized to be a vibrant civic enterprise with untapped power, a capacity for impact, and a moral obligation

to engage. As Laura Raicovich has argued, if museums are to function as cultural spaces that truly reflect our values, they cannot simply remain neutral, "especially as the very foundations of democracy seem to be crumbling around us."[1] For Raicovich and other activists, neutrality is itself a deliberate position that supports the status quo at a time when there can be no bystanders. As it concerns the fate of the museum, the activist rationale is uncompromising: "No museum is neutral, nor has it ever been. Indeed, from their very outset, museum structures have reflected a vast inequity of both power and wealth."[2] Some activists, such as Hannah Baker and the group Decolonize This Place (DTP), go much further, calling for the complete abolition of cultural institutions in their current form as a necessary step for building anew.

Although implicated in the work of DTP and various other groups, museums themselves are generally not the ultimate objective; rather, they are seen as part of a larger project. As DTP has argued: "We refuse to acknowledge the separation of the museum from the rest of society."[3] For these groups, museums exemplify various societal inequities, and thus are part of a larger problem. At the same time, their very success as public institutions has made them highly visible platforms to be used for expressing other demands, including racial justice, indigenous rights, a free Palestine, degentrification, and global wage equity, among others. In September 2021, during United Nations Week in New York, an assembly of activist groups marched on the Museum of Modern Art, splattering its entrances with red paint while demanding the release of Palestinian prisoners in

Israel. Recent protests have also focused on particular institutions for their own objectionable practices, including in 2017 the Dana Schutz controversy at the Whitney; in 2018 protests at The Met and the Guggenheim by artist Nan Goldin in response to the Sacklers' role in the opioid crisis; and in spring 2021, "Strike MoMA," a ten-week initiative led by DTP in partnership with other activist groups.

There is, of course, a strong counterargument that museums are not neutral on the major issues before us; but neither were they intended to serve as partisans in political conflict, especially on matters that do not directly concern the institutions' art-related missions. If the activists represent one side of the current divide, the other is held by those who support a more traditional, circumscribed role for the museum, and who advocate for incremental progress as part of a larger, more evolutionary process of change.[4] Those who would preserve a more limited role for the museum recognize the vulnerability of the institutions they have built and, more generally, the fragility of civilization itself. Indeed, most museums with historical materials are filled with objects that bear witness to the momentary quality and eventual fragility of all civilizations, even those that were once believed to be indestructible, such as those of ancient Assyria, Rome, or even Napoleonic France. In contrast to the activists, the preservationists embrace the Enlightenment heritage of their institutions—imperfect though it surely is—while recognizing as well that it is easier to tear down than it is to build. This is one lesson that every museum teaches us. Most preservationists would acknowledge the need for meaningful change in order to

make museums more open, accessible, and universal, although they may disagree on the degree of change that is needed or the particular agenda required to get there. As argued in a recent essay by Allen Guelzo and James Hankins, culture (and by implication the structures that support it) is a living idea that must evolve along with the society that sustains it. Doing so requires preservation of the "moral and spiritual resources that generate loyalty to recognized authorities and allow individuals to actualize their full potential as human beings. The spiritual resources of a civilization provide those who share them with an identity that transcends the identity belonging to individual peoples united merely by common descent. They produce a common culture that may last many centuries and even outlive the collapse of civilizational order."[5]

The preservationist argument is neither a claim for neutrality nor is it a defense of the status quo, but rather it advocates for thoughtful, incremental change, ideally through a process that is deliberate and inclusive. Throughout this book I have referred to that process as shared governance, which is by definition widely consultative, and in practice often discursive and slow. If museum activists would have us abolish what we have built in favor of something new and more equitable, the preservationists would have us acknowledge the value of what we already have while working to make it better—even if there may be disagreement about how much change is actually needed. In my view, the debate can be most productive when it focuses on pathways for improvement rather than demands for radical deconstruction. For the activist, the museum should function as a political arena and

an essential participant in the ongoing work of the community. For the preservationist, the museum should be a place primarily for art, a sanctuary where anyone can find peace and inspiration, learning and community, and at least at some distance from the cares of the day. As a civic enterprise dedicated to the public good, like Gaius Asinius Pollio's bold experiment within the walls of the Atrium Libertatis, the museum can take us to other places—real and imaginary—that might provide solace, enlarge our understanding, or help us find common ground. If the vision is a good one, the challenge is to make that experience available and meaningful to those who have not yet been included.

In the past few years, I have observed with increasing unease that the debate around the role and purpose of museums is, for the most part, not taking us to common ground as much as it is hardening into a yawning divide, characterized by strident rhetoric and intransigence on both sides. If our objective is to engage all voices to find new approaches that work, we will need to find a better path forward. I am comforted by the observation that museums have proven to be resilient, in the past and today, because what they do matters to the communities that built them and are responsible for sustaining them. During the past two centuries, as we have continued to evolve our society—leaning more often than not in the direction of progress—we have cultivated more enlightened values and identified new priorities that have shaped our museums. In so doing, we have asked our museums to help us find the way forward with new ideas, understand more about our past, or simply engage the world around us. Through it all, museums have continued, almost uniquely in our society, to offer

us access to beauty, a sense of purpose, and perspectives that are larger than ourselves. The resilience of the museum idea derives from the core values that inspired it in the first place and that have guided its work for generations: a progressive vision to be of service; openness to new artistic ideas and diverse cultures; a commitment to rigorous investigation and respectful presentation; governance by the community; independence; and a commitment to endure. Through the years, we have learned that creativity flourishes in an environment that supports freedom of thought and expression, openness to new ideas, and serious engagement, but not dogmatism. The museum is at its best when it is supported by a pluralistic society that values true diversity and community, but not tribalism. It is therefore something of a paradox that the greatest risk to the museum today derives from its very success, which has made it a visible, soft target—even if it is also a beloved one—for those seeking platforms for radical societal change.

For these reasons above all, my own view is that we are facing not so much an existential conflict as an ideological one, even if the stakes are high. To be sure, the American art museum is at a crossroads, which we might define as a "dramatic and morally fraught turning point," as it is being challenged to revisit its mission and purpose.[6] If art museums were once seen primarily as sanctuaries for the quiet contemplation of art—even if such an antiquated conception is illusory—the demand from all sides is for museums to embrace their roles as civic institutions of influence to help bring needed change to a nation that is in serious crisis on multiple fronts and that has lost confidence in

the capacity of government to lead and in many institutions to operate truly in the public interest. For these reasons, there can be agreement among all who care about museums that change is needed and that, as Raicovich has outlined, the best way forward is simply to begin, while acknowledging: "It is never going to be perfect work, but we must see the imperfection as good, as spaces of possibility within which to grow and learn; to sit within this vulnerable space and resist shutting down and cancelling simply because that is easier."[7]

This is, above all, why museums matter: because they can, through collective effort, self-awareness, and a commitment to progress, take us to better places while preserving our history and culture, as they must. Precisely because of the important role they have come to play in our society, we have a moral obligation to preserve our museums while making them more responsive to the needs of our world, just as we have done in the past. As a way forward, our objective should not be to regulate or restrict the debate, which will certainly ensue anyway—perhaps helping us all to find clarity or better purpose—but rather to lead by doing the work that we do best.

9

museums for a new generation

In the years ahead, I believe that for museums to meet the needs of our society, and ideally to thrive, our efforts must focus on making progress in four major areas. Each of these pathways forward can contribute to meaningful progress while helping us to meet the challenges that we are productively able to confront.

1. The first area is for major museums with large and diverse collections to continue the work of becoming more universalist in outlook and approach, being reflective at once of the multitude of cultures around us and their infinite points of intersection, and using scholarship and diverse narratives to bring to life a more textured and interconnected understanding for our audiences.

2. The second area is to adapt our work to meet the needs of the present moment and the various audiences that we are aiming to reach. To be relevant in the sense that we are engaging a wide and disparate public is not necessarily to be preoccupied with the fashionable or the trendy, but rather to be alert to the lived experiences of the communities we are here to serve and to do our best to reach them where they are. This is as much about how we welcome visitors to the museum itself or support them virtually on our websites as it is about the specific programs that we offer.

3. The third area requires us to take the long view with regard to our reason for being, acknowledging that we have special obligations as perpetual institutions and stewards of our cultural history. As a result, we must be sustainable in how we plan for the future, set specific objectives, and use our limited resources. As a museum leader, I am especially mindful of the ethical obligation we have to respect the generations that will come after us by preserving resources that were intended for them.

4. The fourth area asks us to reflect more deeply on how we operate as citizens of the world to generate better ideas for connecting with and being of service to others. If we are truly to embrace a universalist vision, we must seek out new and more innovative ways of collaborating with partners around the world—museums and other mission-driven organizations, governments, local communities, and individuals. There are myriad ways that the American museum can

be of help to others and, along the way, find new approaches to their own work and service to mission. Such approaches, although not without various kinds of risk, will inevitably help us to become better versions of ourselves and more connected citizens of the world.

The Universalist Museum

Building a museum-quality art collection is almost always the work of generations. In addition to a discerning eye for quality and a serious commitment to scholarship, museum leaders must also be passionate collectors, thoughtful and patient negotiators, and, for the most part, well-resourced. Even with all of these conditions in place, the task of filling a museum with exceptional objects representative of various historical periods and disparate geographies is usually the work of lifetimes. For the earliest American museums, most of which were established in the latter half of the nineteenth century, this task was all the more difficult given limited financial resources and modest founding collections, as well as various other limitations on their access to art for acquisition. By contrast, the most established museums and galleries of Europe were, more often than not, converted large-scale royal or aristocratic collections that had been in development for centuries or even, as in the case of the Vatican, for millennia. Most American collections were created with a strong civic vision to be of service but not much of a cultural legacy to bring it to life.

Like everything else about American art museums, collection development became an evolving project, beginning in the early years with modest aspirations, at least with respect to quality, focused more on filling galleries than on the acquisition of masterpieces that, on their artistic merits alone, might inspire an interested public. In the early years at The Met, for example, the goal was exceptionally modest: to display objects of sufficient aesthetic interest to educate and inform a local citizenry that was, for the most part, neither trained nor experienced in looking at art. In practice, this meant that the galleries of early museums contained many objects that were truly undistinguished and even a few plaster casts, which were modeled on originals displayed in European museums. For The Met and other American museums, success during the early years—as measured by rising visitor numbers and heightened levels of donor support—inspired greater ambition on the part of boards, directors, and curators to build collections that were both deeper and more expansive, and that were highlighted by increasing numbers of aesthetically accomplished works. With time, museum leaders developed the skills needed to build more ambitious collections, and they devoted increasing amounts of time and resources to the task. Beginning modestly, they soon immersed themselves in this work, pursuing various strategies simultaneously, including opportunistic purchases on the open market; staffing and underwriting archaeological excavations where, until the mid-twentieth century, the practice of partage made it legal to remove a portion of the discovered materials; and, most important, through the practice of securing

major gifts from individuals who had amassed important collections themselves in selected areas of art. At The Met, there are many areas of great strength in our collections that came from such major gifts by individuals, including, for example, more than six thousand works of medieval and Byzantine art from J. P. Morgan; the early modern paintings and minor arts from Robert Lehman; and, more recently, the unparalleled assembly of cubist paintings promised by Leonard Lauder. In each of these examples, through the gifts of a single donor, The Met's holdings in a particular area were transformed, placing these collections within the ranks of the finest in the world, as they are today.

Ultimately, highly focused acquisition strategies undertaken by private collectors as well as museums afforded new opportunities to build selective collections in the United States that rivaled the best in the world. Examples include the early modern paintings assembled by industrialist Henry Clay Frick, and now in his eponymous museum, or the celebrated Matisse collection at the Baltimore Museum of Art, given by the sisters Claribel and Etta Cone. For the newly ambitious American museums, general economic prosperity and the coincident emergence of prolific art collectors—who were themselves increasingly drawn to philanthropy, which was subsidized by the tax deductibility of charitable contributions—led to extraordinary acceleration in the growth and quality of museum collections throughout the land, and especially in the major cities. With time, experience, and good fortune, many American museums evolved their modest and mediocre collections toward something grander and

more ambitious. By the middle of the twentieth century, the new ambition for many of these museums was to become "encyclopedic," a designation signaling the desire to possess the art of *every* culture—even if thoughtful people recognized that such coverage was actually impossible to achieve, even for the largest and wealthiest of institutions. As collections grew, and with them curatorial and conservation expertise, museums became increasingly self-conscious about the contradiction involved in labeling a collection "encyclopedic" that was inevitably selective; they eventually acknowledged the harm done in making such representations to a diverse public disappointed in not finding the art of *their* culture or tradition within its walls. This is why the term "universalist museum" is both more accurate and represents a better way forward.

In order to achieve such a goal, the universalist vision must be sustained over generations, which requires museum boards and leaders to remain committed to the values of an open, accessible institution where ideas can live, debate is fostered, and difference is seen as a source of strength. The inevitable growth in size and diversity of collections also requires that museums invest in building the expertise needed to do justice to the complexity and historical richness of their new objects and the cultures that produced them. Without proper curatorial oversight of collections, the art and the public are both done a serious disservice. The resources required to support such growth is significant, but this must remain among the highest-priority objectives for the museum. Without a collection that can inspire interest and en-

gagement in the first place, everything else the museum does will be compromised. Respect for the material requires investment in proper care and serious scholarship.

Finally, universalism requires a thoroughgoing commitment to pluralism, from the composition of the museum's board and senior leadership team to the audiences it engages and the programs it offers. If the goal of universalism is for the institution to reflect the cultural richness and human diversity of the world around us, the institution itself must model that aspiration in the decisions it makes about who gets to participate in the work itself. Without the voices of a diverse range of lived experiences, professional perspectives, cultural ideas, and artistic voices, the museum will never be up to the task of achieving true unity of vision or fulfillment of mission.

Remaining Relevant

All art museums, regardless of the character of their collections or content of their programs, prioritize engaging the public to inspire learning and heighten appreciation of works of art and the cultures that produced them. Throughout the history of the American museum, which is now approaching two centuries for the oldest of them, we have had to think carefully about how to reach people in order to make such experiences possible. We have learned that we must remain alert to changes in our society and the evolving interests of the public, especially as we have sought to expand our target audiences and become more welcoming and inclusive. To be sure, in the early days, many

museums—The Met included—may have appeared to be little more than cultural mausolea, filled with beautiful and mysterious objects that invited quiet contemplation, admiration, and, to be sure, some level of intimidation for those who were unfamiliar with the museum's foundational idea or the history of art. That phase did not last for long.

In recent years at The Met we have pursued various strategies to build audiences depending on the groups we are trying to reach. For example, to engage more people from local communities, we have offered on-site programs to schoolchildren as a means of introducing them to our collections and clarifying the visiting process itself, while also encouraging them to return with their families. The Costume Institute exhibition program and our celebrated annual gala have generated significant new audiences among groups that are interested primarily in fashion but might be unfamiliar with the wider collections of the museum. Once these visitors enter the museum for the first time, they are often inclined to experience more of what we have to offer, eventually making repeat visits. In each of these instances and numerous others, we have tried to connect with people where they would be most receptive and then provide them with a better sense of all that we have to offer, which is often a revelation. For a great many people, the greatest barrier to entry is just making a first visit, which to be successful, must be welcoming and ideally engage some area of their particular interest.

For most of their history, American museums have been dedicated to finding the right balance between inspiring a deep educational experience of great art and connecting with people

where they are. Too much emphasis in either direction runs the risk of limiting our ability to connect in meaningful ways. Nearly two decades ago, Philippe de Montebello, former director of The Met, argued something that remains true today:

> The increased focus on visitors carries with it an interesting paradox, namely, that when the visitor, as opposed to the work of art, occupies center stage, he is likely to be less well served, not better served. As the museum strives to attract him and please him, he will, inevitably, be catered to. That is, to ensure that he is counted at the gate, he will not be challenged. Instead, most likely he will be greeted, through the programs that are offered, at his present level of artistic sophistication. By definition, that is not a broadening or enhancing experience of the kind that we are obligated by mission to provide.

Montebello went on to make an essential point about trusting the public to rise to the occasion, saying: "The public knows full well the difference between pabulum served up to entice it into the museum . . . and programs born of seriousness of purpose and true educational motivation. What is in question here is not the art museum's need to be responsive to the public—for it goes without saying that it should—but public approval based on trust, on the visitor's sense that he is not being pandered to. . . . It is by treating our visitors with respect that we will gain theirs."[1]

A preoccupation with being relevant also affects the ways museum narratives are constructed. In an era that is increasingly and disconcertingly self-involved, when the push for relevancy permeates our scholarly work, we risk losing the opportunity to go beyond our own experience for genuine learning about difference. This point was well-observed in a recent review by Robert

Simon of The Met's Medici exhibition, in which he reflected on "the long-established, but now questioned, principle that the art of a historical period can best be understood and appreciated through an awareness of the political, cultural, and social contexts in which it was created. Such a belief no longer accords with the prevailing dogma of the moment, which demands contemporary relevancy. Instead of a confident assumption that the past can illuminate the present, many are now insisting that the present be reflected in the past."[2]

If museums can continue to reach out to increasingly diverse audiences and find *authentic* ways of connecting them to the wonders of their collections and the intellectual excitement of their programs, then they will be able to cultivate, in the fullness of time, an increasingly attentive and trusting public that appreciates the distinctiveness of their offerings among the bewildering and often banal array of discretionary experiences available to them.

Envisioning a Strong Future

Just as the museum must be focused on remaining accessible and relevant to diverse audiences, so too must it ensure that it is financially strong, independent, and committed to being sustainable. Most universalist and other kinds of museums were designed to be perpetual institutions, serving their communities for the long term, across generations and throughout time. This is a complex proposition, requiring leadership structures to be stable and responsive to the various constituencies that have an

interest in their work, which usually requires a high-functioning system of shared governance that is seen to be credible to the various communities it serves. With committed leadership, a mission that resonates with audiences, and a consultative governance process in place, the museum is in a strong position to adapt to changing circumstances and to respond thoughtfully to new demands. The key factor for a sustainable future is credible and engaged leadership aligned with mission and connected to the communities it serves. The most compelling critiques before museums today are based on the view that these elements are not adequately in place.

A related challenge facing most museums concerns their capacity to remain financially sustainable over the long term. The essence of the problem—which is as relevant for universities and other nonprofit organizations as it is for museums—is a historic imbalance between the growth rate of expenses and that of revenues, a problem sometimes referred to as a structural deficit, which is based mostly on factors tied to the general economy and outside the control of the institution. On the cost side of the equation, it is inevitably the case that a great many of the expenses generated by the museum—including compensation for skilled labor as well as investments in information technology, building materials and facilities infrastructure, and scholarly and scientific materials, as well as various other programmatic expenses—all rise at rates in excess of the cost of living (what we sometimes call inflation, as measured by the Consumer Price Index, or CPI). These costs rise and fall based on external markets in which museums must operate, but in which they have no di-

rect control. In the past, these expenses have consistently risen at rates well above the overall rise in the economy as measured by the CPI. For example, during the past twenty-five years, wages for professional staff and programmatic expenses within the museum have risen at more than twice the rate of the CPI. Over the long term, museums must keep pace with these costs in order to prosper. If a given institution is unable to meet competitive compensation levels, with time it will inevitably fall behind in hiring and retaining a strong professional staff; if it lacks the resources needed to invest in critical infrastructure (roofing, information technology, air-conditioning and humidity control systems, and so on), it will be unable to keep the museum secure and its collections adequately protected. For the most part, these are not costs that are easily reduced without serious consequences, which can include diminished essential services or deferred maintenance, which imposes an unfair burden on future generations. Rather, these are all investments the museum is obligated to make on an ongoing basis.

In order to meet these expenses, the museum must rely on comparable growth in revenues or it risks eroding long-term assets (such as endowments or other reserve funds, or even collections if they are allowed to be deaccessioned for sale to support operating expenses) or diminishing needed services. For most independent museums, meaning those that are not owned or operated by governmental entities, revenues are generated primarily through ticket sales and visitor services such as restaurants, parking, and retail offerings, as well as through fundraising. For various reasons, the growth of revenues from these various ac-

tivities, especially admissions ticket sales, do not generally keep pace with the overall rise in costs, resulting in an imbalance in operating budgets that, over time, can deplete the institution in various ways. I have seen various approaches that have been deployed to increase revenues or reduce costs that have an adverse impact on the character of the museum and the nature of its offerings. These include increasingly commercial offerings aimed at generating ever-larger audiences willing to pay for some new kind of entertainment or amenity, but that risks compromising a more ambitious educational or programmatic agenda. Another, more invidious risk of growing budget deficits is increasing inequities in wages for the general staff, or alternatively, a reduction in the number of staff without a commensurate reduction in overall workload or institutional activity level. The longer-term consequences of commercialization or growing wage inequities include erosion of mission and diminished levels of trust from staff and the public.

Having spent most of my professional career as a leader in museums and higher education, I have learned that the "cost disease" problem—which is how economists describe the phenomenon of disproportionate expense growth in highly skilled, mission-driven organizations—is both difficult and complex. Yet it is possible to manage the problem if careful and comprehensive long-term planning is part of an ongoing discipline for the institution and its leaders. Such planning must include detailed analysis of the components of the museum's budget, incorporating such elements as required investments in facilities and collections care, specific program plans, and projected staffing levels

with sufficient resources allocated for competitive compensation. This work must be done using a shared governance model, where primary responsibility resides with the administration; but this must also include staff participation for goal-setting and detailed project-planning, as well as board oversight of annual budgets coupled with multiyear projections to identify potential issues down the road. Rising costs that grow into massive deficits can generally be identified and addressed early on if responsibilities are fully defined and accountability is clear. One common mistake that I have seen over the years is for boards to assume that exercising their fiduciary oversight is more pro forma than substantive. Good boards are actively engaged in financial planning and budget work, ask difficult questions, and make sure the museum is on a healthy and sustainable path. Like so many other aspects of museum work, as I have noted throughout this book, the way forward is to uphold a genuine commitment to shared governance, transparency, and accountability. Unlike the federal government, the museum does not have the option of persistent deficit spending, resulting in excessive and unsustainable levels of debt. Within the museum, we are accountable to people with whom we live and work, who should not give us the latitude to squander resources or disregard the rights of future generations.

The most enduringly important factor in determining a strong future for the museum is the most intangible of assets, and that is trust. For the museum successfully to engage the public at levels required for meaningful personal experiences, and to steward resources that have been provided by the community, there must be a strong sense among all stakeholders that the right val-

ues are in place, leadership is operating with integrity, and the primary leadership objective is to fulfill the stated mission in a clear and discernable manner. Doing so does not require that the museum's programs be easy or lacking in controversy, nor does it mean that everyone must be satisfied. To the contrary, as a vital part of a real community, the museum should be at the forefront in advancing its mission in the world around us. The ultimate goal that the museum be a trusted institution makes it more, not less, likely that we can convene difficult discussions, explore controversial ideas, and connect across difference because we recognize that the museum is a shared resource at the center of what we all value in a free society. This is why the museum fails in its larger public mission if it falls into a narrower role of advocacy for partisan causes rather than advancing a commitment to pluralism and shared governance as a path to a better future.

Pursuing a Collaborative Model

As we complete the first two centuries of our history, the American art museum is widely recognized to be a distinctive achievement in the cultural world and an essential part of the communities that built them. Through our own growth and progress, and especially in recent years, we have become increasingly aware of how interconnected we all are, as evidenced within the disparate collections in our own institutions as well as more broadly throughout the world and across the arc of human civilization. The more we learn about our art and ourselves, the clearer it is that we are all connected—there are no outliers. As Kwame

Anthony Appiah has argued, "All cultural practices and objects are mobile; they like to spread, and almost all are themselves creations of intermixture."[3] Appiah goes on to observe what is increasingly evident: that "culture is messy and muddled, not pristine and pure."[4]

If the universal idea is increasingly resonant with the knowledge and values of museums today, it also serves as a compelling vision for how we can build stronger connections with others. The museum of the future will find meaning in difference and power in unity, with each culture represented within its collections recognized as part of a great constellation, both distinctive and interconnected. There are innumerable ways to realize this global vision, and much new evidence that this movement is already well underway, from the recent announcement of Berlin's commitment to collaborate on Benin material with Nigeria, to ongoing partnerships such as The Met's archaeological research project in Egypt, now beginning its second century. The collaborative model offers immense opportunity, limited only by our imaginations and capacity to engage others beyond our institutions. From long-term loans and shared ownership agreements to collaborative exhibitions and research projects, we will find new ways of working and learning from others, while at the same time fostering meaningful connections between people, across political and national divides. If we are increasingly connected to others for our exploration and work, we will foster more equitable and balanced approaches to realizing our mission and serving our audiences.

As we look toward an uncertain and challenging future, it is difficult to predict with confidence how museums will change or what they may become for succeeding generations. I am less concerned with making such predictions than I am with preserving the values that inspire our work and evolving the processes that allow us to do it with integrity and transparency, which is the most effective means of enlarging our vision of what is possible. If our greatest asset is trust, we must have greater credibility with our communities than we do now, which will require difficult work in the years ahead. As I look at the world around us today, I am wary of what lies ahead as we inevitably confront a long list of seemingly intractable problems, both within our nation and beyond. However, I am optimistic about what our museums can do in the way of progress and constructive change, to help each of us to live more rewarding lives and, along the way, build a stronger community. Only good things can come from heightened opportunities for shared learning and a greater awareness by all of the fragility of the human condition and the myriad ways we are interconnected. At a time when we desperately need institutions that authentically serve the public good and are genuinely accountable to us all, the museum matters now more than it ever has.

notes

INTRODUCTION

1. The earliest American art museum is the Wadsworth Atheneum in Hartford, Connecticut, founded in 1842.

ONE: ANCIENT ANTECEDENTS

1. See Massimiliano Franci, "Towards the Museum: Perceiving the Art of 'Others' in the Ancient Near East," in *Museum Archetypes and Collecting in the Ancient World,* ed. Maia Wellington Gahtan and Donatella Pegazzano (Leiden: Brill, 2015), 22.

2. Paris, Musée du Louvre, Département des Antiquités orientales, AS 6065.

3. See Franci, "Towards the Museum," 20–21.

4. See Maia Wellington Gahtan and Donatella Pegazzano, "Museum Archetypes and Collecting: An Overview of the Public, Private, and Virtual Collections of the Ancient World," in Gahtan and Pegazzano, *Museum Archetypes,* 2.

5. John Boardman, *The Archaeology of Nostalgia: How the Greeks Re-Created Their Mythical Past* (London: Thames and Hudson, 2002), 20.

6. Pausanias, *Description of Greece,* Boeotia, 40.11, in Pausanias, *Description of Greece,* trans. W. H. S. Jones, The Loeb Classical Library (Cambridge, MA: Harvard University Press, 1977), 4:360–61.

7. Boardman, *Archaeology of Nostalgia,* 8.

8. Pausanias, *Description of Greece,* Attica, 22.4–7, in Pausanias, *Description of Greece,* trans. W. H. S. Jones, The Loeb Classical Library (Cambridge, MA: Harvard University Press, 1979), 1:108–11.

9. Boardman, *Archaeology of Nostalgia,* 14.

10. See Josephine Shaya, "Greek Temple Treasures and the Invention of Collecting," in Gahtan and Pegazzano, *Museum Archetypes,* 30.

11. Museo Archeologico Nazionale di Reggio Calabria.

12. See Margaret M. Miles, *Art as Plunder: The Ancient Origins of Debate about Cultural Property* (Cambridge: Cambridge University Press, 2008), 105–51.

13. See Miles, *Art as Plunder,* 260–63. The destruction of Jerusalem is described vividly in Josephus, *The Jewish War,* 6.230–442, in Josephus, *The Jewish War,* trans. H. St. J. Thackeray, The Loeb Classical Library (Cambridge, MA: Harvard University Press, 1997), 6:244–305.

14. Quoted in Miles, *Art as Plunder,* 212.

15. For an overview on the life of Gaius Asinius Pollio, see Llewelyn Morgan, "The Autopsy of C. Asinius Pollio," *Journal of Roman Studies* 90 (2000): 51–69. Quintilian is quoted in n3.

16. See Paolo Liverani, "The Culture of Collecting in Roma: Between Politics and Administration," in Gahtan and Pegazzano, *Museum Archetypes,* 72.

17. Morgan, "Autopsy," 66.

18. Quoted in ibid.

19. See Miles, *Art as Plunder,* 238–40; and Morgan, "Autopsy," 66.

20. Suetonius, *The Lives of the Caesars, Augustus,* 29.5. See https://penelope.uchicago.edu/Thayer/E/Roman/Texts/Suetonius/12Caesars/Augustus*.html

1. Quoted in Tristan Weddigen, "The Picture Galleries of Dresden, Düsseldorf, and Kassel: Princely Collections in Eighteenth-Century Germany," in *The First Modern Museums of Art: The Birth of an Institution in 18th- and Early-19th-Century Europe,* ed. Carole Paul (Los Angeles: J. Paul Getty Museum, 2012), 145.

2. For a recent comprehensive study, see Ritchie Robertson, *The Enlightenment: The Pursuit of Happiness, 1680–1790* (New York: Harper, 2021).

3. Jürgen Habermas, *The Structural Transformation of the Public Sphere: An Inquiry into a Category of Bourgeois Society* (Cambridge, MA: MIT Press, 1991); and Paul, *First Modern Museums,* xi.

4. For a full account of the Temple and the Grand Tourists who visited it, see Cyril Aldred, "The Temple of Dendur," *Metropolitan Museum of Art Bulletin* 36, no. 1 (Summer 1978): 1–80.

5. Ibid., 59.

6. Elizabeth Vassall Fox Holland, *The Journal of Elizabeth Lady Holland (1791–1811),* ed. Giles Stephen Holland Fox-Strangways Ilchester (London: Longmans Green, 1908).

7. Ibid., 141.

8. Paul, *First Modern Museums,* viii, 22.

9. Carole Paul, "Capitoline Museum, Rome: Civic Identity and Personal Cultivation," in Paul, *First Modern Museums,* 24.

10. Quoted in ibid.

11. See Robert G. W. Anderson, "British Museum, London: Institutionalizing Enlightenment," in Paul, *First Modern Museums,* 47–71.

12. Quoted in John Pope-Hennessy, *British Museum Guide* (London: British Museum, 1980), 8.

13. For a comprehensive account, see B. F. Cook, *The Elgin Marbles* (London: British Museum, 1997), 68–92.

14. See, for example, Christopher Hitchens, *The Parthenon Marbles: The Case for Reunification* (London: Verso, 2008), 17–106.

15. See Andrew McClellan, "Musée du Louvre, Paris: Palace of the People, Art for All," in Paul, *First Modern Museums,* 213–35.

16. Quoted in ibid., 217.

17. For an account of Napoleon's career as an art thief, see Cynthia Saltzman, *Plunder: Napoleon's Theft of Veronese's Feast* (New York: Farrar, Straus and Giroux, 2021).

18. See, for example, Christopher M. S. Johns, *Antonio Canova and the Politics of Patronage in Revolutionary and Napoleonic Europe* (Berkeley: University of California Press, 1998), 185–90.

19. Ibid., 194.

20. Quoted in McClellan, "Musée du Louvre," 233.

THREE: THE AMERICAN EXPERIMENT

1. The founding of The Met is admirably recounted in Calvin Tomkins, *Merchants and Masterpieces: The Story of the Metropolitan Museum of Art* (New York: Henry Holt, 1989). For the Fourth of July celebration in Paris, see ibid., 28. See also Karl E. Meyer, *The Art Museum: Power, Money, Ethics—A Twentieth Century Fund Report* (New York: William Morrow, 1979), 25–28.

2. Tomkins, *Merchants and Masterpieces,* 21.

3. For an overview on the early years of the Museum of Fine Arts, Boston, and The Met, see Kathleen Curran, *The Invention of the American Art Museum: From Craft to Kulturgeschichte, 1870–1930* (Los Angeles: Getty Research Institute, 2016), 52–79, 80–109.

4. Quoted in Tomkins, *Merchants and Masterpieces,* 16–17.

5. See Joanne Pillsbury, "Aztecs in the Empire City: 'The People without History' in The Met," *Metropolitan Museum Journal* 56 (2021): 14.

6. Tomkins, *Merchants and Masterpieces,* 12.

7. Edward Gibbon, *The Decline and Fall of the Roman Empire* (New York: Alfred A. Knopf, 1993), 1:39.

8. See Meyer, *Art Museum,* 256–60.

9. Ibid., 256.

10. This report was issued in 1869 by the "Art Committee" of the Union League Club of New York, which was under the leadership of club president John Jay, who had assumed responsibility for advancing the museum idea. See Tomkins, *Merchants and Masterpieces,* 29.

FOUR: A PLACE OF CONSEQUENCE

1. Quoted in Maggie Fergusson, ed., *Treasure Palaces: Great Writers Visit Great Museums* (New York: Economist/Public Affairs, 2016), x.

2. Kathleen Curran, *The Invention of the American Art Museum: From Craft to Kulturgeschichte, 1870–1930* (Los Angeles: Getty Research Institute, 2016), 81–82.

3. Alain de Botton, *The Architecture of Happiness* (New York: Vintage International, 2006), 152.

4. Leah Hsiao, "The Battle of the Pyramid: Architectural Criticism on I. M. Pei's Louvre Pyramid," Mapping Architectural Criticism, https://mac.hypotheses.org/leah-hsiao.

5. This idea is explored in de Botton, *Architecture of Happiness,* 62.

6. Kerstin Barndt, "Working through Ruins: Berlin's Neues Museum," *Germanic Review* 86, no. 4 (2011): 295.

7. Ibid., 307.

8. Carmen Bambach, conversation with author, April 6, 2021.

9. Ibid.

10. Elyse Nelson, conversation with author, April 5, 2021. See also Nelson's essay in the exhibition catalogue: "Sculpting about Slavery in

the Second Empire," in *Fictions of Emancipation: Carpeaux's* Why Born Enslaved! *Reconsidered,* ed. Elyse Nelson and Wendy S. Walters (New York: Metropolitan Museum of Art, 2022), 48–59.

11. Sheena Wagstaff, conversation with author, March 16, 2021.

12. Ibid.

13. Victoria Newhouse, Letter to the Editor, *New York Times,* December 3, 2010.

14. Jason Farago, "The Frick Savors the Opulence of Emptiness," *New York Times,* February 25, 2021.

15. James Panero, "Sublet with Bellini," *New Criterion* 39, no. 8 (2021): 56.

16. Paul Goldberger, *Why Architecture Matters* (New Haven: Yale University Press, 2009), 38–40.

17. Ibid., 43.

FIVE: A FORUM FOR IDEAS

1. Jürgen Habermas, *The Structural Transformation of the Public Sphere: An Inquiry into a Category of Bourgeois Society* (Cambridge, MA: MIT Press, 1991).

2. Ibid., 31.

3. For an alternative opinion on the importance of coffeehouses, see Ritchie Robertson, *The Enlightenment: The Pursuit of Happiness, 1680–1790* (New York: Harper, 2021), 358–65.

4. Habermas, *Structural Transformation,* 36–37.

5. Ibid., 36.

6. Quoted in ibid., 135.

7. Jonathan Rauch, *Kindly Inquisitors* (Chicago: University of Chicago Press, 2013), 68.

8. The topic of "cancel culture" is now the source of heated debate

between liberals and conservatives. The literature on the subject is growing exponentially. For a recent account, see Anne Applebaum, "The New Puritans," *Atlantic,* October 2021, 60–70.

9. Jonathan Rauch, *The Constitution of Knowledge: A Defense of Truth* (Washington, DC: Brookings Institution, 2021), 189–231.

10. For the Garrels story, see Julia Halperin, "Gary Garrels, the San Francisco Museum of Modern Art's Longtime Chief Curator, Resigns amid Staff Uproar," Artnet News, July 11, 2020, https://news.artnet .com/art-world/gary-garrels-departure-sfmoma-1893964.

11. Rauch, *Kindly Inquisitors,* 56.

12. Anthony Kronman, *The Assault on American Excellence* (New York: Free Press, 2019), 102.

13. Habermas, *Structural Transformation,* 137.

14. See, for example, Kronman, *Assault on American Excellence,* 39.

15. Ronald K. L. Collins and David M. Skover, *On Dissent: Its Meaning in America* (Cambridge: Cambridge University Press, 2013), xi.

16. See Robin Pogrebin, "Upheaval over Race Reaches the Met Museum after Curator's Instagram Post," *New York Times,* June 24, 2020.

17. Christiansen's letter is quoted in ibid.

18. Alexis de Tocqueville states with striking clarity and prescience the issue before us today, as quoted in Rauch, *Constitution of Knowledge,* 197.

19. Habermas, *Structural Transformation.*

20. James Cuno, *Museums Matter: In Praise of the Encyclopedic Museum* (Chicago: University of Chicago Press, 2013), 112–13.

21. "The Whitney Announces Curators for 2017 Biennial," press release, Whitney Museum of Art, https://whitney.org/2017-biennial -curators.

22. For a recent, detailed account of the Emmett Till case and its aftermath, see Susan Neiman, *Learning from the Germans: Race and the Memory of Evil* (New York: Farrar, Straus and Giroux, 2019), 211–58.

23. For background on the controversy, see Randy Kennedy, "White Artist's Painting of Emmett Till at Whitney Biennial Draws Protests," *New York Times,* March 21, 2017; and Lorena Muñoz-Alonso, "Dana Schutz's Painting of Emmett Till at Whitney Biennial Sparks Protest," Artnet News, March 21, 2017, https://news.artnet.com/art-world/dana-schutz-painting-emmett-till-whitney-biennial-protest-897929.

24. Quoted in Alex Greenberger, "'The Painting Must Go': Hannah Black Pens Open Letter to the Whitney about Controversial, Biennial Work," ARTNews, March 21, 2017, https://www.artnews.com/artnews/news/the-painting-must-go-hannah-black-pens-open-letter-to-the-whitney-about-controversial-biennial-work-7992/.

25. Roberta Smith, "Should Art That Infuriates Be Removed?" *New York Times,* March 27, 2017.

26. Coco Fusco, "Censorship, Not the Painting, Must Go: On Dana Schutz's Image of Emmett Till," *Hyperallergic,* March 27, 2017, https://hyperallergic.com/368290/censorship-not-the-painting-must-go-on-dana-schutzs-image-of-emmett-till/.

27. See Kennedy, "White Artist's Painting."

28. Greenberger, "'Painting Must Go.'"

29. Ibram X. Kendi, *How to Be an Antiracist* (New York: One World, 2019), 95.

30. Peter Schjeldahl, "The Dark Revelations of Gerhard Richter, *New Yorker,* March 9, 2020, https://www.newyorker.com/magazine/2020/03/16/the-dark-revelations-of-gerhard-richter.

31. Rauch, *Kindly Inquisitors,* 146.

32. Zadie Smith, "Getting In and Out: Who Owns Black Pain?" *Harper's,* July 2017, https://harpers.org/archive/2017/07/getting-in-and-out/.

33. Neiman, *Learning from the Germans,* 257–58.

34. Lauren Elkin, "Showing Balthus at the Met Isn't about Voyeurism,

It's about the Right to Unsettle," *Frieze,* December 19, 2017, https://www.frieze.com/article/showing-balthus-met-isnt-about-voyeurism-its-about-right-unsettle.

35. Mia Merrill, "Metropolitan Museum of Art: Remove Balthus' Suggestive Painting of a Pubescent Girl, Thérèse Dreaming," Care2-Petitions, thepetitionsite.com.

36. Sarah Sze, interview, *CBS Sunday Morning,* aired May 2, 2021.

SIX: AN ENTERPRISE FOR COMMUNITY

1. This concern was raised by S. Dillon Ripley at the time he was serving as secretary of the Smithsonian: "Museums would do well to measure their independence against their eventual dependence on government funds." Quoted in Karl E. Meyer, *The Art Museum: Power, Money, Ethics—A Twentieth Century Fund Report* (New York: William Morrow, 1979), 14.

2. A. Bartlett Giamatti, *The University and the Public Interest* (New York: Atheneum, 1981), 4–5.

3. For background on The Met's admissions policy, see Meyer, *Art Museum,* 105–17. For the first seventy years of the museum's history, visitors were charged admission two days per week.

4. These were essentially the same arguments made by the museum in 1971 when the pay-as-you-wish policy was implemented. See Meyer, *Art Museum,* 110.

5. The city was contributing about 25 percent of The Met's operating budget in 1965–66, when the museum still offered free admissions.

6. Here too I would acknowledge that all donations to nonprofit organizations are indirectly subsidized by the government through the benefit of tax deductions.

7. For the Sackler matter, see Sarah Cascone, "In a Landmark Move, the Metropolitan Museum of Art Has Removed the Sackler Name from Its Walls," Artnet News, December 9, 2021, https://news.artnet

.com/art-world/met-museum-removing-sackler-name-2046380. See also "The Metropolitan Museum of Art and Sackler Families Announce Removal of the Family Name in Dedicated Galleries," press release, December 9, 2021, Metropolitan Museum of Art, https://www.metmuseum.org/press/news/2021/the-met-and-sackler-families-announce-removal-of-the-family-name-in-dedicated-galleries.

8. On museum governance, see Marie C. Malaro, *Museum Governance: Mission, Ethics, Policy* (Washington, DC: Smithsonian Institution, 2012).

9. For an excellent overview on the role of boards, see William G. Bowen, *The Board Book: An Insider's Guide for Directors and Trustees* (New York: W. W. Norton, 2008).

10. A useful framework for board governance is offered by Boardsource, "The Source: Twelve Principles of Governance That Power Exceptional Boards," in *Reinventing the Museum: The Evolving Conversation on the Paradigm Shift,* ed. Gail Anderson (Lanham, MD: Altamira, 2012), 473–75.

11. Meyer, *Art Museum,* 224.

12. On museum deaccessioning generally, see Malaro, *Museum Governance,* 50–59.

13. See Robin Pogrebin and Zachary Small, "Selling Art to Pay the Bills Divides the Nation's Art Museum Directors," *New York Times,* March 19, 2021.

14. Hannah Baker, "We Should Abolish Museums Now," *Hyperallergic,* May 27, 2021, https://hyperallergic.com/649011/we-should-abolish-museums-now/.

15. Sebastian Smee, "Can Artists Right the Ills of an Unjust World by Staging Museum Protests?," *Washington Post,* July 23, 2019.

16. Laura Raicovich, *Culture Strike: Art and Museums in an Age of Protest* (London: Verso, 2021).

17. Tristram Hunt, "Museums Must Confront the Big Issues," *Art Newspaper,* December 20, 2018.

1. Quoted in Calvin Tomkins, *Merchants and Masterpieces: The Story of the Metropolitan Museum of Art* (New York: Henry Holt, 1989), 17.

2. Quoted in ibid., 16.

3. Quoted in ibid., 17.

4. See Joanne Pillsbury, "Aztecs in the Empire City: 'The People without History' in The Met," *Metropolitan Museum Journal* 56 (2021): 14.

5. Kwame Anthony Appiah, *The Lies That Bind: Rethinking Identity* (New York: Liveright, 2018), 196.

6. Joanne Pillsbury provides an insightful and nuanced account of the civic purpose of collection building at The Met during the early years. See Pillsbury, "Aztecs and the Empire City," 12–31.

7. Susan Neiman, *Learning from the Germans: Race and the Memory of Evil* (New York: Farrar, Straus and Giroux, 2019), 377.

8. For an account of the acquisition and subsequent discovery that the Euphronios Krater (also known as the Sarpedon Krater) had been looted, see Nigel Spivey, *The Sarpedon Krater: The Life and Afterlife of a Greek Vase* (Chicago: University of Chicago Press, 2019), esp. 16–43.

9. See Nicholas Gage, "How the Metropolitan Acquired 'The Finest Greek Vase There Is,'" *New York Times*, February 19, 1973.

10. Spivey, *Sarpedon Krater*, 31. See also Karl E. Meyer, *The Art Museum: Power, Money, Ethics—A Twentieth Century Fund Report* (New York: William Morrow, 1979), 117–18; and Thomas Hoving, *Making the Mummies Dance* (New York: Simon and Schuster, 1993), 315.

11. See also Elisabetta Povoledo, "Ancient Vase Comes Home to a Hero's Welcome," *New York Times,* January 19, 2008.

12. Colin Moynihan, "Met Museum to Return Prize Artifact Because It Was Stolen," *New York Times,* February 15, 2019.

13. Much has been written about the issue of the "Gold Coffin" and the role of Matthew Bogdanos, chief of the Antiquities Trafficking Unit

in the office of the Manhattan District Attorney, in uncovering the fraud. See, for example, "The Tomb Raiders of the Upper East Side," *Atlantic,* November 23, 2021, https://www.theatlantic.com/magazine /archive/2021/12/bogdanos-antiquities-new-york/620525/.

14. For a thorough background on the Benin Bronzes, two recent studies are helpful: Dan Hicks, *The Brutish Museums: The Benin Bronzes, Colonial Violence, and Cultural Restitution* (London: Pluto, 2021); and Barnaby Phillips, *Loot: Britain and the Benin Bronzes* (London: Oneworld, 2021).

15. It is worth noting that the actual looting of the Benin material occurred only two years before fifty-one nations (including Britain) signed the Hague Convention, which outlawed all looting, seizure, or damage to cultural property during war. See Phillips, *Loot,* 104.

16. Catherine Hickley, "And So It Begins: Germany and Nigeria Sign Pre-Accord on Restitution of Benin Bronzes," *Art Newspaper,* October 15, 2021.

17. See Peggy McGlone, "Smithsonian to Give Back Its Collection of Benin Bronzes," *Washington Post*, March 8, 2022.

18. See, for example, Valentina Di Liscia, "In Ceremony, Met Museum Officially Returns Benin Bronzes to Nigeria," *Hyperallergic,* November 22, 2021, https://hyperallergic.com/694341/met-museum -officially-returns-benin-bronzes-to-nigeria/.

19. David Bromwich, *Moral Imagination: Essays* (Princeton, NJ: Princeton University Press, 2014), 41.

20. Appiah, *Lies That Bind,* 208.

21. Ibid., 211.

22. Hicks, *Brutish Museums,* 200–208, 233.

23. Neiman, *Learning from the Germans,* 384.

24. See Pillsbury, "Aztecs in the Empire City," 26.

1. Laura Raicovich, *Culture Strike: Art and Museums in an Age of Protest* (London: Verso, 2021), 9.

2. Ibid., 42.

3. "Faxxx," Decolonize This Place, https://decolonizethisplace.org/faxxx-1.

4. See, for example, the interviews on the subject of the future of museums with twenty-eight institutional leaders in András Szántó, ed., *The Future of the Museum: 28 Dialogues* (Berlin: Hatje Cantz, 2020).

5. Allen C. Guelzo and James Hankins, "Western Civilization, I: Civilization and Tradition," *New Criterion* 40, no. 1 (September 2021): 4.

6. Ibid., 3.

7. Raicovich, *Culture Strike,* 168.

1. Philippe de Montebello, "Art Museums, Inspiring Public Trust," in *Whose Muse? Art Museums and the Public Trust,* ed. James Cuno (Princeton, NJ: Princeton University Press; Cambridge, MA: Harvard University Art Museums, 2004), 157–60.

2. Robert Simon, "The Medici: Portraits and Politics, 1512–1570," *Burlington Magazine* 163 (September 2021): 845.

3. Kwame Anthony Appiah, *The Lies That Bind: Rethinking Identity* (New York: Liveright, 2018), 208.

4. Ibid., 210.

acknowledgments

I have been a dedicated museum person for most of my life, but I have learned the most about these remarkable places during my years at The Met, where I have been privileged to work with a truly extraordinary group of colleagues. I am deeply grateful for what they have taught me, for their support of this project, and, most important, for the example of their passionate commitment to an idea that continues to matter a great deal. For assistance in matters large and small, I would like to thank Dita Amory, Carmen Bambach, Jordan Bean, Sharon Cott, Sarah Graff, Seán Hemingway, Max Hollein, Quincy Houghton, Alisa LaGamma, Griff Mann, Lavita McMath Turner, Elyse Nelson, Diana Patch, Joanne Pillsbury, Sheena Wagstaff, Ken Weine, and my indefatigable colleagues in the Watson Library, who found a way to support my research from inside a closed museum during a global pandemic. For advice and wisdom outside of The Met, I would like to express my gratitude to David Chipperfield, Sandra Jarva Weiss, Peter Osnos, and Philippe de Montebello, with whom I enjoyed many insightful conversations. I am especially grateful to Glenn Lowry, who took a lively interest in this project from the outset and has been a superb interlocutor. My mother, Leah Tchack, one of the world's most insightful readers, offered much support and constructive advice.

This project has benefitted in myriad ways from Samuel Schapiro and Maria Fillas, both of whom served as superb research assistants, even when we were all homebound and otherwise preoccupied. I offer my gratitude to my agent and friend Karen Ganz, herself a devoted museum visitor, for her advice and enthusiastic support for this project. I would also like to thank Marina Kellen French and my friends at the American Academy in Berlin who invited me to give a lecture on the subject of museums during the early days of this project. My stimulating and entirely enjoyable visit there inspired me to proceed with this book, even as the Covid pandemic became a bleak and tenacious distraction in all of our lives. Indeed, I am deeply grateful to John Donatich and Katherine Boller at Yale University Press, who first proposed this project, which has provided a most welcome opportunity for reflection and learning while also serving as a heartening reminder of our shared humanity in the midst of much fragmentation and despair. I have received excellent support from the team at Yale University Press, including Heidi Downey, Laura Hensley, and Raychel Rapazza.

This project, like everything else in my life, is made possible by my remarkable family, who have supported me for as long as I can remember. I am grateful to my sons, Joel and Teddy, and especially to my wife, Sandra, more than I can say. Finally, I dedicate this book to my Met colleagues and to Bill Bowen, who was for me a beloved friend and constant inspiration. Although not exactly a museum person, Bill would have understood the point of this project and, I would like to believe, would have observed his influence throughout these pages.

index

abolition of museums, 120, 146

Académie Royale de Peinture et de Sculpture, Paris, 34

accountability, 101, 117, 119, 136, 165

Acropolis, Athens, 15, 27, 60

activism, centered on museums, 101, 121–22, 130, 140, 146–49

Adams, John Quincy, 26

admissions policies, 104–8, 164

Albani, Alessandro, 29

Alexander the Great, 16

Altes (Old) Museum, Berlin, 59–60

American Museum of Natural History, New York, 110

ancient Near East, 11, 32–33

Appiah, Kwame Anthony, 127, 139, 166–67

archaeologists, 32

architecture, of museums, 55–63

Arch of Titus, Rome, 18–19

Ark of the Covenant, 18

art collecting: in the ancient world, 11–22; by British Museum, 31–34; ethics of, 33, 37–40, 119, 130–37; Eurocentric basis of, 126–28; expansion of, beyond Western culture, 128, 137–42, 152; by the Louvre, 37–39, 42; by The Met, 46; museums' long-term commitment to, 154–55, 157; in public museums, 5; tax laws related to, 46, 156, 177n6; in United States, 19–21, 154–57. *See also* colonialism; cultural property; plunder

Art Institute of Chicago, 3, 45

Ashmolean, Oxford University, 28

Association of Art Museum Directors (AAMD), 114–16

Athens: Acropolis, 15; Parthenon, 27, 33; Porch of the Caryatids, 60

Atrium Libertatis, Rome, 21, 149

Augustus, 26

Baker, Hannah, 120, 146

Balthus (Balthasar Klossowski), 96–98; *Thérèse Dreaming*, 96

Baltimore Museum of Art, 156

Bambach, Carmen, 66–68

Barndt, Kerstin, 61

Beccaria, Cesare, 24

behavioral racism, 93–94

Bellini, Giovanni, *St. Francis in the Desert*, 72

Bellows, Henry, 126

Benin Bronzes, 133–36, 140, 167, 180n15

Black, Hannah, 92–95

Black Lives Matter, 85

Blanchard, Thérèse, 96

blockbuster exhibitions, 64–65

Boardman, John, 13–14, 16

boards of trustees, 111–19, 165

Boston, 129

Botton, Alain de, 57

Bradish, Luther, 26, 28

Breuer, Marcel, Whitney Museum of American Art building, 69–73

Bright, Parker, 92–95

British Museum, London, 2, 30–34, 41, 77, 129, 130

Bromwich, David, 138

Byron, George Gordon, Lord, 27, 33

Caesar, Julius, 19–20

Campbell, Thomas, 115

cancel culture, 76, 80–81

Canova, Antonio, 39

Capitoline, Rome, 2, 28–31, 41, 42

Capponi, Alessandro Gregorio, 29–30

CEOs. *See* chief executive officers

change, in museums, 58–59

Change the Museum (CTM), 120

chief executive officers (CEOs), 111–12

Chipperfield, David, 60–62

Choate, Joseph C., 44, 125

Christiansen, Keith, 85–87

Cicero, 17–19

civic and political role of museums: community-oriented, 99–124; contemporary, 145–46; ethical import of, 73–74; in Greece, 13–14; importance of, 6, 20–21, 41, 145–46; intellectual exchange as component of, 75–98; in Rome, 20–22; in United States, 43–45. *See also* public sphere

Clement XII, Pope, 29–30

Cleopatra, 26

collaboration, museums' practice of, 166–67

collecting. *See* art collecting

Collins, Ronald, 84

colonialism, 32–33, 37, 119, 129, 133–34, 140–41. *See also* cultural property

Comfort, George Fisk, 126

common ground/humanity, 6, 8, 73, 78, 80, 89, 123, 139–41, 148–49, 166–67

community resource, museums as, 99–124; accountability concerns, 101, 117, 119; critiques and recommendations, 119–24, 168; economic aspect of, 100; funding of, 106–9; ideal of, 141; leadership of, 111–19; The Met and, 159; as motive of museum antecedents, 22; representativeness as issue for, 113–14, 119; strategies for, 102, 153;

US museums, 44, 46–49, 99–101, 153, 159–60, 168

Cone, Claribel and Etta, 156

controversy: admissions-related, 107–8; cultural property–related, 33, 37–40, 47, 119, 130–36; over deaccessioning, 114–16; donor-related, 109–11; Elgin Marbles, 33; exchange of ideas and, 2, 68, 75–76, 78–79, 81–82, 85–87, 90–96; the Louvre and, 38–40, 58–59; The Met and, 68, 85–87, 90, 96–98, 107–8, 110–11, 131–33, 147; museums as site of, 2, 75–76, 95; race-related, 68, 81–82, 85–87, 90–96; San Francisco Museum of Modern Art and, 81–82; trust related to, 166; universalism vs. particularity, 140; Whitney Biennial and, 90–96

Corcoran Gallery, Washington, D.C., 3

cost disease, 164

Costume Institute, Metropolitan Museum of Art, 159

Cottonian Library, 31

Covid pandemic, 114, 145

cultural identity, 41, 138–42

Cultural Institutions Group, 107

cultural property: controversies over, 33, 37–40, 47, 85, 119, 130–36; legal issues concerning, 17, 32, 39–40, 130, 133–34, 136, 180n15; in museum collections, 33, 37–40, 119, 129, 130–37; Napoleon's plundering of, 38–39. *See also* colonialism; plunder

culturism, 138

Cuno, James, 89

Curran, Kathleen, 56

Cyrus the Great, 12

deaccessioning, 114–16

Decolonize This Place (DTP), 120, 146–47

Delphi, sanctuary of, 7–8, 15

democracy, museums in relation to, 5–6, 14, 43–46. *See also* civic and political role of museums

Denon, Vivant, 38–39, 42

Dickens, Charles, 27

donors, 109–11, 156

DTP. *See* Decolonize This Place (DTP)

Dyke, Anthony van, 35

economic contributions of museums, 1, 100

education and intellectual exchange: controversy associated with, 2, 68, 75–76, 78–79, 81–82, 85–87, 90–96; cross-cultural, 55, 138–39, 141; as function of museums, 20–22, 25, 32, 34, 38, 48, 54–55, 75–99, 138–39; as function of US museums, 42–46, 48, 125–26, 159; personal growth and transformation, 54–55, 57–58, 67, 72–73, 138, 160; rules of engagement for, 77–89, 94–95

Eiffel, Gustave, and Eiffel Tower, 59

Elgin, Thomas Bruce, 7th Earl of, 27, 33

Elgin Marbles, 27, 33

Elkin, Lauren, 97
encyclopedic museums: American,
130, 138, 154–57; British Museum,
31–32, 34; collecting practices of,
119, 152; and cultural identity,
138–42; evolution of, 59; Louvre,
34, 38, 42; The Met, 69, 128;
museums' practical commitment
to, 158; nature of, 5, 38, 56, 59, 89,
139–42, 154–58, 167; universalist
vs., 157
endowments, 108, 118, 163
Enlightenment: American prac-
tice of principles of, 43–44, 47;
betrayal of ideals of, 37–38, 40;
French Revolution as outgrowth
of, 35–36; leading figures of, 24;
museums as outgrowth of, 2, 11,
12, 30–31, 34–38, 89, 130, 142, 147;
principles and ideals of, 24, 37–38,
60, 78, 89, 129, 142; progressiv-
ism of, 31, 41, 43–44, 142; public
sphere as outgrowth of, 25, 77–78;
Western-centrism of, 128–29
ethics and values: critiques of
museum operations, 120; and
cultural property controversies,
37–40, 119, 130–36; exhibitions'
foregrounding of, 68; Greek
sanctuaries as manifestation of,
7–8; museums as manifestation
of, 2, 44, 73–74; obligation for
preservation of museums, 151, 153.
See also accountability; transpar-
ency; trust
Euphronios Krater, 131–32
Eurocentrism, 126–28

exhibitions. See blockbuster exhibi-
tions; special exhibitions

Farago, Jason, 72
Farnese Bull, 20
finances: admissions policies and,
104–8; boards' engagement in,
165; collecting practices sup-
ported by investment in, 157–58;
deaccessioning and, 114–16;
operating expenses, 105–6, 114–16,
162–65; revenue sources, 104–8,
163–64; sources of funding and,
103–4, 106–7, 109–11, 117–18; and
sustainability, 162–65
Fine Arts Museums of San Fran-
cisco, 115
First Temple, Jerusalem, 18
Floyd, George, 81, 85, 229
Fox, Elizabeth Vassall (Lady Hol-
land), 27
Franklin, Benjamin, 24
freedom of thought and discourse,
20–21, 75–81, 87
French Revolution, 35
Frick, Henry Clay, 156
Frick Collection, New York, 71–73,
156
fundamentalism, 87–88
funding. See finances
fundraising, 108–11
Fusco, Coco, 92

Garrels, Gary, 81–82
Germany, return of cultural prop-
erty by, 135, 167
Getty, 132

Giamatti, A. Bartlett, 104
Gibbon, Edward, 24, 28, 45
Goethe, Johann Wolfgang von, 24, 28
Goldberger, Paul, 74
Gold Coffin of Prince Nedjemankh, 132
Goldin, Nan, 147
government, funding provided by, 47, 99, 103
Goya, Francisco, 94
Grand Tour, 25–29, 31, 41
Great Library of Alexandria, 19
Greece, 7–8, 13–16
Guelzo, Allen, 148
Guggenheim Museum, New York, 110, 147

Habermas, Jürgen, 25, 77–79, 88, 95
Hague Convention, 180n15
Hammurabi, 12
Hankins, James, 148
Harleian Library, 31
Harries, Karsten, 73–74
Hicks, Dan, 140
Hitchens, Christopher, 33
Hobbes, Thomas, 24
Homer, 14
Hoving, Thomas, 63–65, 131
humanity. See common ground/ humanity
Hume, David, 24, 80
Hunt, Tristram, 122

ideas. See education and intellectual exchange
identity. See cultural identity; nation-building and national identity
identity politics, 140

Jay, John, 42–43, 173n10
Jewish Wars, 18
Josephus, 18

Kant, Immanuel, 24
Kendi, Ibram X., 93–94
Kimbell Art Museum, Fort Worth, 101
Klemm, Gustav Friedrich, 24
Kronman, Anthony, 83

La Font de Saint-Yenne, Étienne, 34
Lauder, Leonard, 156
Layard, Austen Henry, 32
leadership, 111–19
Lehman, Robert, 156
Lenoir, Alexandre, 85
Leonardo da Vinci, Mona Lisa, 64
Lew, Christopher Y., 90–92
Lin, Maya, Vietnam Veterans Memorial, 94
Locke, John, 78
Locks, Mia, 90–92
looting. See plunder
Louis XVI, King, 35
Louvre, Paris: author's experiences of, 58–59; controversies at, 38–40, 57–58, 110; educational and intellectual function of, 77; founding of, 2, 30–31, 34–36; as model for museums, 30, 41–42, 129; Pei redesign of, 58–59, 70; works and collections in, 12, 37–39, 129, 130

manubiae, 17–18, 21. *See also* plunder

Mark Antony, 26

Matisse, Henri, 156

Merrill, Mia, 96–98

Metropolitan Museum of Art, New York (The Met): admissions policy of, 104–8; archaeological research in Egypt by, 167; architecture of, 55–56; author's affiliation with, 4, 5, 55, 97–98, 107–8, 110–11, 132–33; community outreach of, 159; controversies at, 68, 85–87, 90, 96–98, 107–8, 110–11, 131–33, 147; Costume Institute, 159; economic contributions of, 100; educational and progressive mission of, 43–46, 77; encyclopedic character of, 2; founding of, 2, 42–44, 47, 101, 125–29; funding for, 104–8; mission of, 46, 108, 111, 125–29; special exhibitions at, 63–68; use of Breuer's Whitney building by, 69–71; visitor experiences at, 55, 63–68, 159; works and collections in, 26, 46, 55–56, 125–29, 131–33, 136, 137, 155–56

Meyer, Karl, 46, 113

Michelangelo, 66–67; *Pietà*, 64

Michelangelo: Divine Draftsman and Designer (exhibition, New York, 2017–18), 66–68

Middle Ages, 23–24

Mill, John Stuart, 78–79

mission of museums: civic, 44–45; commitment to/fulfillment of, 46, 48, 101–2, 109–11, 113, 118, 121–22, 142, 147; community-oriented, 99–102, 109; cultural preservation as, 48, 85–87, 122, 137, 147–49, 153; educational, 42–46, 48, 125–26; ethical, 74; evolution of, 36, 47, 117, 118, 122, 141; finances linked to, 105, 107–10; intellectual-cultural, 75–76, 84, 87–90; leadership linked to, 111, 113–14, 117–18; The Met, 46, 108, 111, 125–29; person-oriented, 45, 54, 84; threats to, 105, 108, 164; in United States, 2–3, 7, 42–49, 74, 99–101, 126–30, 169n1

Montebello, Philippe de, 132, 160

Monumenta Pollionis, Rome, 21, 149

Morgan, J. P., 46, 156

Morgan, Llewelyn, 20

Mould, Jacob Wrey, 56

Museum Island, Germany, 59–61

Museum of Fine Arts, Boston, 2, 43–45, 101

Museum of Modern Art, New York, 103, 146–47

museums: abolition of, 120, 146; activism centered on, 101, 121–22, 130, 140, 146–49; antecedents of, 7–8, 11–22; change and permanence in, 57–59; collaborative efforts of, 166–67; contemporary challenges facing, 3–5, 7, 47–49, 76, 119–24, 145–47, 150; emergence of modern European, 2, 28–41; encyclopedic/universal,

5, 31–32, 34, 38, 59, 89, 119, 128, 130, 138–42, 152, 154–58, 167; European compared to US, 2–3, 42–47, 99, 126–27, 129, 137, 145, 154; future of, 120–24, 149, 152–54, 161–68; ideals and aspirations upheld and nurtured by, 44–45, 53–55, 57–58, 72–74, 123, 141, 148, 149–51, 160, 168; leadership of, 111–19; relevance of, 158–61; significance of, 1–3, 5, 8, 151, 168; sustainability of, 48, 55, 74, 103–4, 107, 111, 123, 149, 153, 157, 161–65; in United States, 2–3, 7, 42–49, 74, 99–101, 145, 150, 154–56, 166, 169n1; as works in progress, 48, 56, 74, 151. *See also* civic and political role of museums; community resource, museums as; finances; mission of museums; place and space, museums as; places of consequence; visitor experiences

Napoleon, 37–38, 40
Naram-Sin, 12
National Archaeological Museum, Athens, 15
National Gallery of Art, Washington, D.C., 57, 103
National Museum of African Art, Washington, D.C., 135
National Portrait Gallery, London, 110
National Socialism, Germany, 61
nation-building and national identity: as motive of museum antecedents, 13–15, 22; museums as component of, 1, 2, 41, 44
Nebuchadnezzar II, 11–12, 18, 38
Nefertiti, bust of, 62–63
Neiman, Susan, 95, 129, 141
Nelson, Elyse, 68
Neo-Babylonian Palace of Nebuchadnezzar II, 11–12
Neues (New) Museum, Berlin, 59–62
neutrality, of museums in civic context, 121–22, 146–48
Newhouse, Victoria, 70
New-York Historical Society, 26
Nigeria, 133–36, 167
Nimrud, Neo-Assyrian palace at, 32
Nineveh, Neo-Assyrian palace at, 32

Old Royal Collection, 31
Olympia, sanctuary of, 7–8, 15
ownership of art. *See* cultural property

Palestinian issues, 146
Panero, James, 72
Panhellenism, 7
Parthenon, Acropolis, Athens, 27, 33
Pausanias, 14, 15
Pei, I. M., 57–59, 70
Peirce, Charles Sanders, 83
permanence, museums associated with, 48, 54, 57–59, 75, 123, 153, 161
Perseverance Rover (rocket), 88
Philadelphia Museum of Art, 3, 45
Pillsbury, Joanne, 44, 126, 141–42
Pio Clementino, Vatican, 31

place and space, museums as, 53–74;
Breuer building, 68–73; build-
ings, 55–63; diverse characteristics
of, 53–54; ethical character of,
73–74; interiors, 63–73; Louvre,
58–59; meaning and significance
of, 53–55; The Met, 55–56, 63–68;
National Gallery of Art, 57;
Neues Museum, 59–63
places of consequence, museums
as, 53–74; civic, 99; ethical, 74;
personal, 53–54, 57, 67–68
Pliny, 21
plunder, 12, 17–18, 21, 37–39. *See also*
colonialism; cultural property
pluralism, 89, 104, 140, 150, 158,
166
Pollio, Gaius Asinius, 20–21, 30,
149
Pope, John Russell, 57
Porch of the Caryatids, Acropolis,
Athens, 60
preservation, as museums' mission,
48, 85–87, 122, 137, 147–49, 153
progressivism: of Enlightenment
thought, 31, 41, 43; museums
associated with, 3, 31, 41, 43–44,
46, 76, 77, 121, 123, 129, 142, 150;
in United States, 43–44, 46, 129;
universalism and, 142
property. *See* cultural property
provenance of objects, 13–14
public good, 6, 22, 42–43, 46, 103,
125, 149, 168
public opinion, 84
public sphere, 25, 49, 76–89, 92
Purdue Pharma, 110

Quintilian, 20

race, 68, 81–82, 85–87, 90–96, 119,
140
Raicovich, Laura, *Culture Strike*,
121–22, 146, 151
Raphael, 35
Rassam, Hormuzd, 32
Rauch, Jonathan, 79, 80–81, 95
Rawlinson, Henry, 32
Reign of Terror, 35
Richter, Gerhard, *Birkenau Paint-
ings*, 94
Rijksmuseum, Amsterdam, 15
Ripley, S. Dillon, 177n1
Roche, Kevin, 56
Rome, 16–21, 28–30, 45
Rubens, Peter Paul, 35
rules of engagement, 77–89
Ruskin, John, 31–32

Sackler family, 110–11, 147
sanctuary, museum as, 2, 53–54, 75,
149, 150
San Francisco Museum of Modern
Art, 81–82
Sarr, Felwine, 135
Savoy, Bénédicte, 135
Schjeldahl, Peter, 94
Schutz, Dana, *Open Casket*, 90–96,
147
Second Temple, Jerusalem, 18
Serota, Nicholas, 54
shared governance, 111–17, 123, 148,
162, 165
Shutruk-Nahhunte, 12
Simon, Robert, 160–61

Skover, David, 84
slavery, 68
Sloane, Hans, 31
Smee, Sebastian, 120–21
Smith, Adam, 24
Smith, Roberta, 92
Smith, Zadie, 95
Smithsonian Institution, 103, 132, 135
special exhibitions: in Breuer Building, New York, 69–73; at The Met, 63–68; visitor experiences in, 63–73
Statuario Pubblico, Venice, 28
stele of Hammurabi, 12
stele of Naram-Sin, 12
Stüler, Friedrich August, 60–62
Suetonius, 21
sustainability, of museums, 48, 55, 74, 103–4, 107, 111, 123, 149, 153, 157, 161–65
Sze, Sarah, 98

Tate Britain, London, 15, 110
tax laws, 46, 156, 177n6
Temple of Dendur, Metropolitan Museum of Art, 26, 56
Till, Emmett, 91–94
Till, Mamie, 91–93
time: embodied in museum collections, 55, 57, 62–63; museum architecture as record of, 55–57, 61–63; museums' long-term commitment to collecting, 154–55, 157; visitors' experience of, 73
Titian, 35
Titus, 18–19, 38

Tocqueville, Alexis de, 84, 87
Tomkins, Calvin, 45, 126
tourism: in Greece, 14, 15; in modern Europe and environs, 25–29
trade in art, 16–17, 28–29
Trajan, 21
transparency, 88, 108, 109, 115–17, 122, 136, 165
Treasures of Tutankhamun (exhibition, New York, 1976–79), 65
tribalism, 140–41, 150
trigger warnings, 97–98
Triumphs (public displays of plunder), 18
trust, 112, 117, 160, 164–66, 168
Tutankhamun, 65

Uffizi, Florence, 31
Union League Club of New York, 173n10
United Nations Week, 146
United States: European museums compared to those of, 2–3, 42–47, 99, 126–27, 129, 137, 145, 154; museums' vision and mission in, 2–3, 7, 42–49, 74, 99–101, 126–30, 137, 145, 150, 154–56, 159, 166, 169n1; political and cultural crises of, 4, 119, 145, 150–51, 168
universalist museums. *See* encyclopedic museums

values. *See* ethics and values
Vaux, Calvert, 56
Verres, Gaius, 17–18
Victoria and Albert Museum, London, 77, 110, 122

visitor experiences: author's own,
 58–59, 62–63, 70; in Breuer Build-
 ing, New York, 72–73; content of
 collections as factor in, 137–38;
 factors contributing to, 54; at
 The Met, 55, 63–68, 159; personal
 significance of, 53–55, 57–58,
 72–74, 138; relevance as concern
 of, 158–61; in special exhibitions,
 63–73; temporal aspects of, 73;
 varieties of, 53–54
visitors. *See* tourism
Voltaire, 24

Wadsworth Atheneum, Hartford,
 Connecticut, 101, 169n1

Wagstaff, Sheena, 69–70
Wales, Prince of, 27
War Revenue Act (1917), 46
Wellington, Duke of, 40
white box spaces, 66–68
Whitney, Gertrude Vanderbilt, 90
Whitney Biennial, 90–93, 96, 147
Whitney Museum of American Art,
 New York, 69
World's Fair (New York, 1964), 64
World War II, 60

Zuccaro, Anna, 96–97

Daniel H. Weiss is president and chief executive officer of The Metropolitan Museum of Art. Formerly the president of Haverford and Lafayette Colleges and professor of art history at Johns Hopkins University, he holds a Ph.D. from Johns Hopkins and an MBA from the Yale School of Management. This is his seventh book.

Featuring intriguing pairings of authors and subjects, each volume in the **Why X Matters** series presents a concise argument for the continuing relevance of an important idea.

Also in the series

Why Acting Matters	David Thomson
Why Architecture Matters	Paul Goldberger
Why Arendt Matters	Elisabeth Young-Bruehl
Why Argument Matters	Lee Siegel
Why Baseball Matters	Susan Jacoby
Why the Constitution Matters	Mark Tushnet
Why Dance Matters	Mindy Aloff
Why the Dreyfus Affair Matters	Louis Begley
Why Food Matters	Paul Freedman
Why the New Deal Matters	Eric Rauchway
Why Niebuhr Matters	Charles Lemert
Why Poetry Matters	Jay Parini
Why Preservation Matters	Max Page
Why the Romantics Matter	Peter Gay
Why Surrealism Matters	Mark Polizzotti
Why Translation Matters	Edith Grossman
Why Trilling Matters	Adam Kirsch
Why Writing Matters	Nicholas Delbanco